Ink

THE NOT-JUST-SKIN-
DEEP GUIDE TO
GETTING A TATTOO

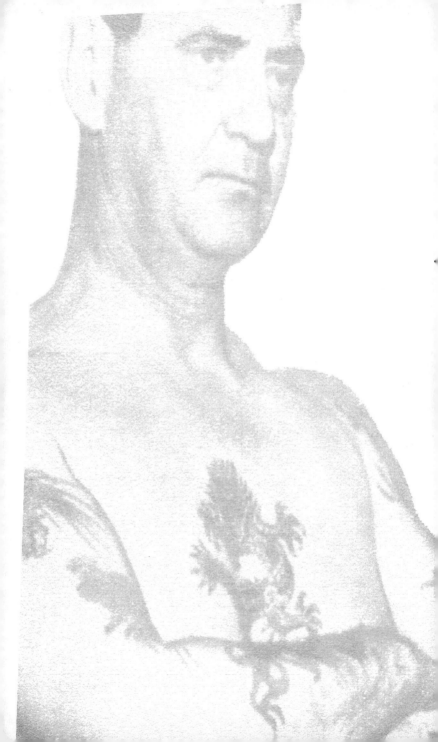

INK

THE
Not-Just-Skin-
Deep Guide to

Getting
a Tattoo

Terisa Green, PH.D.

NEW AMERICAN LIBRARY

New American Library
Published by New American Library, a division of Penguin Group (USA) Inc., 375 Hudson Street,
New York, New York 10014, USA
Penguin Group (Canada), 90 Eglinton Avenue East, Suite 700, Toronto,
Ontario M4P 2Y3, Canada (a division of Pearson Penguin Canada Inc.)
Penguin Books Ltd., 80 Strand, London WC2R 0RL, England
Penguin Ireland, 25 St. Stephen's Green, Dublin 2, Ireland (a division of Penguin Books Ltd.)
Penguin Group (Australia), 250 Camberwell Road, Camberwell, Victoria 3124,
Australia (a division of Pearson Australia Group Pty. Ltd.)
Penguin Books India Pvt. Ltd., 11 Community Centre, Panchsheel Park, New Delhi - 110 017, India
Penguin Group (NZ), 67 Apollo Drive, Rosedale, North Shore,
Auckland 1311, New Zealand (a division of Pearson New Zealand Ltd.)
Penguin Books (South Africa) (Pty.) Ltd., 24 Sturdee Avenue,
Rosebank, Johannesburg 2196, South Africa

Penguin Books Ltd., Registered Offices: 80 Strand, London WC2R 0RL, England

First published by New American Library, a division of Penguin Group (USA) Inc.

First Printing, June 2005
10 9

 REGISTERED TRADEMARK—MARCA REGISTRADA

LIBRARY OF CONGRESS CATALOGING-IN-PUBLICATION DATA:

Green, Terisa.
 Ink: the not-just-skin-deep guide to getting a tattoo / by Terisa Green.
 p. cm.
 ISBN 978-0-451-21514-7 (trade pbk.)
 1. Tattooing. I. Title.
 GT2345.G735 2005
 391.6'5—dc22 2004026837

Set in Bodoni Book
Designed by Susan Hood

Printed in the United States of America

PUBLISHER'S NOTE
The publisher does not have any control over and does not assume any responsibility for author or
third-party Web sites or their content.

Introduction

"WE ARE ALL TATTOOED IN OUR CRADLES WITH THE BELIEFS OF OUR
TRIBE; THE RECORD MAY SEEM SUPERFICIAL, BUT IT IS INDELIBLE."

OLIVER WENDELL HOLMES JR.

(1841–1935)

Why this book? Oh, lots of reasons really, but mainly to collect the most current information on tattooing and put it together in one place. When people have the information for an informed choice, there's no excuse for a bad one, and the likelihood of a bad choice is much diminished. Lots of other books concentrate on more extreme forms of body modification, or feature tons of glossy images of tattoos, or are academic treatises full of text and postmodern analysis. The soup-to-nuts, nuts-and-bolts, *non*-nutshell guide to what's involved in getting a tattoo has been conspicuous by its absence. If, like me, you're one of those people who want to do their homework before embarking on the quest for a tattoo, this book collects the widely varying types of information available on the subject. So

Reason #1 for "why-this-book" is to provide all of this information, in one place, for all of us.

Is it altruism that drives this project? Nope. Profit? No to that too, actually. Part collection and part dissemination, this book also aims to answer the questions that people ask about tattooing all the time—plus questions that they don't ask but should. If this book can answer those types of questions, then perhaps people like me and also people in the tattoo industry will be kept from answering those same questions all the time, every day. Of course, people will always have questions, whether they read this book or not. Also, there probably isn't a book that would stop the weird questions that come my way from time to time, since there's really no help for that. (Do I like getting tattooed *because* it's painful? The answer to that has been and continues to be an emphatic "No" . . . but thanks for asking.) Therefore, Reason #2 for "why-this-book" is to try to keep from saying the same things over and over and over and over, again and again.

Disinformation is not only dangerous; it's very irritating. From home remedies to stories with urban legend status, there seems to be no limit to the strange things that people will believe and then repeat. Actually getting to the bottom of something is much more work. It's also much more rewarding. Tattoos, how they change over time, and the process involved in getting one are subjects around which disinformation seems to swirl like the flakes in a snow globe. Reason #3 for "why-this-book" regards putting to rest some of the crap information that seems to appear from nowhere but never goes away.

My first book on tattoos is a cerebral affair. *The Tattoo Encyclopedia: A Guide to Choosing Your Tattoo* is all about tat-

too symbols and their meanings—over eight hundred of them. *Ink* is thus the practical counterpart. Both of these books have been fun and interesting to write, in different ways of course. Thus Reason #4 for this book is for me to have fun.

It's impossible to know how it feels to have a tattoo until you have one. The final reason for this book, in a reverse order sort of importance, is to start the process of inducting people into the tribe. Knowing some of the history of tattooing, seeing some of the factoids, reading about the tattoo milieu, and trying to visualize your own future tattoo put you on the path to not only a tattoo but potentially the perfect tattoo for you. Reason #5 for this book, therefore, is *not* to convince anyone that he or she should or should not have a tattoo; this book is for people who have decided that they want to be inked and are on a mission to obtain the best possible experience and end product that can be imagined.

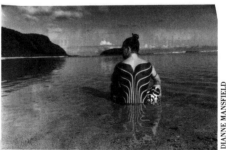

DIANNE MANSFIELD

Tattooist Rory Keating wears a Polynesian-inspired tattoo design done by Leo Zulueta, Spiral Tattoo, Ann Arbor, MI.

Ink

THE NOT-JUST-SKIN-DEEP GUIDE TO GETTING A TATTOO

1 | The Big Three

TATTOOED ON IRENE WOODWARD
(AKA LA BELLE IRENE, ONE OF
THE FIRST FEMALE TATTOOED
CIRCUS ATTRACTIONS, CA 1880)

When you're thinking about getting a tattoo, you're looking at tattoos, or at least you should be. The first part of deciding what type of tattoo you want and where you want to have it involves looking at them wherever you might be able to spot them: on TV, in movies, in magazines, or, best of all, in person. Seeing one up close and in the flesh is really not as difficult as it might seem. Even if you don't know Angelina Jolie, you almost certainly know somebody with a tattoo, since at least one in ten people is tattooed. In fact, the more you look, the more it seems that tattoos are everywhere. Seeing tattoos and being seen when you actually have one is all part of the tattoo dynamic, whether intentional or not. Tattoos naturally attract attention, a curious look or two, and also a set of questions well-known to anybody who has one.

These are the questions that the uninked all share and which invariably first spring to mind when they see someone's tattoo for the first time: Is it real? Did it hurt? Is it permanent? It is no coincidence that the answers to those three questions are at the heart of the tattoo process and of how to go about getting yourself safely and sanely inked.

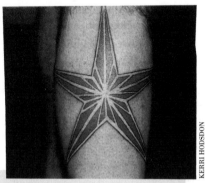

KERRI HODSDON

Variation on the nautical star, by Kerri Hodsdon, Tabu Tattoo, Venice, CA.

Tattoo Trivia: According to the *Guinness Book of World Records*, the most tattooed living man is Tom Leppard of the Isle of Skye, Scotland. He has chosen a leopard skin design, with all the skin between the dark spots tattooed saffron yellow. The area of his body covered is 99.2 percent. • The person with the most individual designs is Bernard Moeller of Pennsylvania, with over fourteen thousand separate tattoos. • The world's most decorated woman is striptease artiste "Krystene Kolorful" (Alberta, Canada). Her 95 percent bodysuit took over ten years to complete.

Is It Real?

Wondering if a tattoo is real or not isn't as silly as it might seem at first. People who are not tattooed or who simply haven't seen many tattoos can sometimes have a difficult time telling the difference. The quality and popularity of other less permanent types of body art are flourishing right alongside that of tattoos. A whole industry of products has arisen to fill the needs of people who are interested in body art but who don't want to commit to something permanent. Body painting kits, temporary tattoos, *mehndi*, and even ordinary felt-tip markers have all been used to create designs on people's bodies. Ironically, as tattoos spread through the populace and, of course, through the celebrity population as well, makeup artists are becoming skilled at covering tattoos, only to then apply a temporary tattoo design that fits the character or movie.

Tattoo Etiquette: The most socially correct reaction when seeing someone's tattoo is to say:

A. "Is it supposed to be all blurry like that? Just kidding."

B. "Who did this fabulous tattoo?"

C. "No, really, I like how it's colored outside the lines."

D. " 'Forever' only has one 'v.'"

ANSWER: **B.** If it's a good tattoo, you've seen the best advertisement that exists for a tattoo studio or artist. If it's bad, you can cross the place off your list.

Interestingly, people will often assume that a tattoo is not real. Again, this is not unreasonable since, despite the entrance of tattooing into the mainstream, tattooed people are still a minority. Also, people who see a tattoo have not been privy to the processes of investigation and decision making that might have led up to it; in other words, it may take them by surprise. They might even harbor some of the old and outdated stereotypes regarding tattooed people—for example, that the group is restricted to sailors and bikers—and not even realize it. All of these mental gyrations add up to an assumption that the tattoo could not possibly be real. But curiosity seems to get the better of almost everybody, although we try to temper it with a cultural desire for politeness, not wanting to stare. An innocuous filler for a gap in the conversation or an opening line in what will turn out to be a conversation about tattoos is simply to ask, "Is it real?"

Tattoo Trivia: 10% of the people in the United States are tattooed.
17% of the people in the United States between the ages of 18 and 24 are tattooed.
35% of NBA players are tattooed.

Is It Permanent?

By definition, no temporary form of body art is a real tattoo. A real tattoo is as permanent as it gets. It is pigment that is inserted under the epidermis (the outer, protective layer of the skin) into the dermis (just below the epidermis, where the sweat glands and blood vessels reside). Once in the dermis, it is captured there by the body, essentially for all time.

What Is a Tattoo?

MAIN ENTRY: tattoo
FUNCTION: noun
INFLECTED FORM(S): plural tattoos
DATE: 1777

1: the act of tattooing : the fact of being tattooed

2 : an indelible mark or figure fixed upon the body by insertion of pigment under the skin, or by production of scars

Captain James Cook, British naval explorer, made landfall as a lieutenant in Australia in April of 1770 (*Picturesque Atlas of Australasia*, 1886).

from the Merriam-Webster Dictionary

According to Merriam-Webster, 1777 is when the word "tattoo," with the meaning of inked images in skin, entered into English usage and was put into the dictionary. However, we can reasonably trace a likely derivation of the word which precedes that given date. We know from the records of the 1769 expedition of James Cook to the South Pacific that there was a Tahitian word *tatau*, which means "to mark." But the actual word "tattoo" existed before Cook and his voyages— about 150 years before.

In a happy coincidence, this previous form of the word meant "a rapid rhythmic rapping" and was used by military personnel, such as Cook and his crew, when referring to the call sounded before taps. The coincidence is a happy one because the sound of tattooing in Tahiti was, in fact, a rapid tapping where the set of needles, looking like a small rake, was hit with a stick to drive ink under the skin. Although the Tahitians

called it *tatau*, Cook and his men likely substituted a near sound-alike word from their own background. The West was forever changed when these early sailors absorbed this part of Tahitian culture and brought tattooed natives, as well as their own tattoos, back with them.

In these days of laser removal techniques, you might assume that nothing on or in the skin is ever really permanent. Do not, however, get a tattoo thinking that you'll be able to remove it later. The laser removal process is very lengthy, still quite expensive, and reportedly rather painful. In fact, it may not be possible to remove a tattoo completely or to remove it without some scarring. Always consider a tattoo very permanent.

Tattoo Lingo Lesson: *virgin—anybody who has never been tattooed.*

Of course, part of the allure and quintessential nature of tattoos is their permanence. Their enduring character suggests something lasting, significant, memorable, and even eternal. At the same time, though, the thought of their permanence often works out to be a major hurdle for most people on their way to actually getting a tattoo. People who are taking the time to give some consideration to their tattoo design are concerned about the fact that it can't be changed, and rightly so. The choice of design, body placement, and colors needs to be something that stands some chance of remaining relevant for a lifetime. It would be ridiculous to suggest that people should pick something about themselves or

their lives that won't change, because all things can and do change, from feelings toward other people to religion, and even gender. The very next chapter starts you out on the process of being able to find your design, choosing something that is relevant and meaningful. It's one of the most important but also one of the most pleasurable parts of the process of getting a tattoo.

That said, however, tattoos do change over time. In fact, not all of the ink inserted into the skin can remain there. Instead, the body will do its best to take some of it away before it becomes permanent (more on this in chapter 4). The majority of the ink, however, is encapsulated and is then subject to the same changes that your skin undergoes. After the

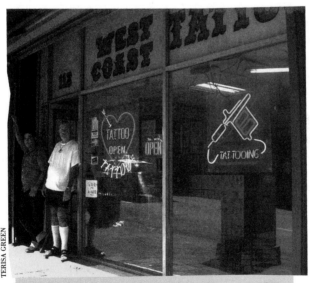

TERISA GREEN

Owner Tennessee Dave (right) and tattooist Sicko in front of West Coast Tattoo, the oldest tattoo studio in California, continuously located in the same location since 1949. Tennessee Dave bought the shop in 1963.

Divine Origin in Tahiti

The published accounts of Reverend William Ellis (1794–1872) document his long career as a missionary in the South Sea Islands and South Africa—a career which saw him master both typography and photography specifically to use the written word and photographs to impress the native peoples he wanted to convert. Trained as a gardener in his youth, he had deep religious feelings that eventually led him to enlist in the foreign ministry, where he combined a genuine interest in the people he served with some talent in both scientific and historic research. Published in 1859, *Polynesian Researches During a Residence of Nearly Eight Years in the Society and Sandwich Islands* includes not only an account of the practices of "tatauing" (tattooing) in Tahiti (the largest and most well-known of the Society Islands, French Polynesia) but also a narrative of its divine origin.

"The following is the native account of the origin of tatauing. Hina, the daughter of the god Taaroa, bore to her father a daughter, who was called Apouvaru, and who also became the wife of Taaroa. Taaroa and Apouvaru looked steadfastly at each other, and Apouvaru, in consequence, afterwards brought forth her firstborn, who was called Matamataaru. Again the husband and the wife looked at each other, and she became the mother of a second son, who was called Tiitiipo. After a repetition of this visual intercourse, a daughter was born, who was called Hinaereeremonoi. As she grew up, in order to preserve her chastity, she was made *pahio*, or kept in a kind of enclosure, and constantly attended by her mother. Intent on her seduction, the brothers invented tatauing, and marked each other with the figure called Taomaro. Thus ornamented, they appeared before their

Tahiti in silhouette, 1920, by the National Geographic Society.

sister, who admired the figures, and, in order to be tataued her-self, eluding the care of her mother, broke the enclosure that had been erected for her preservation, was tataued, and became also the victim to the designs of her brothers. Tatauing thus origi-nated among the gods, and was first practiced by the children of Taaroa, their principal deity. In imitation of their example, and for the accomplishment of the same purposes, it was practiced among men. Idolatry not only disclosed the origin, but sanc-tioned the practice. The two sons of Taaroa and Apouvaru were the gods of tatauing. Their images were kept in the temples of those who practised the art professionally, and every application of their skill was preceded by a prayer addressed to them, that the operation might not occasion death, that the wounds might soon heal, that the figures might be handsome, attract admirers, and answer the ends of wickedness designed."

first three weeks of a tattoo's new life—in other words, after it is completely healed—the sun is a tattoo's biggest enemy. Exposure to ultraviolet light, which we know damages the skin, also damages a tattoo, breaking down the pigment to some extent. The result is obvious: faded tattoos with color becoming less vibrant and also becoming less distinct, per-haps even blurred. The effects of the sun can vary greatly,

however. The bearer of the tattoo controls to what extent the effects of the sun will play a part. Tattoos can also change shape as the body changes, stretching or contracting as the skin does. How long will a tattoo last? As far as is known, tattoos last forever, or at the very least, longer than we live. How long a tattoo will remain vibrant, though, is so variable that it defies a single answer (more on that in chapter 6). Suffice it to say that you and your tattoo will likely spend the rest of your lives together.

Does It Hurt?

The business end of a tattoo machine consists of a set of needles (rarely is it a single needle, by the way, even for a thin line) that rapidly reciprocates up and down, for a very short distance, and introduces ink into the skin through very small punctures. You know it hurts. Actually, everybody really assumes that it does in fact hurt. The real question that is being asked when somebody says "Does it hurt?" is "How much does it hurt?" and "Can I take it?" Without a doubt, different people feel pain to greater and lesser degrees. It's also true that different parts of the body are more and less sensitive. Areas that are fleshy (upper arm, calf, abdomen) tend to feel pain less than areas close to bone (an ankle, elbow, or the spine, for example). Some people will describe it as a hot scratching sensation while others will feel something more acute. Some people will wince and practice a breathing exercise to control the pain while others chat casually and even seem to doze. It's also remarkable how much of an effect your tattoo artist can make, both physically and mentally,

on your experience of pain in the tattoo process (chapter 3). Consider the fact that thirty million people in the US alone have tattoos and that a high percentage of these will get more than one. If the process were unbearably painful, it wouldn't get done.

Current Demographics

Harris Poll, 2003: **16% of adult Americans have at least one tattoo**

ages 18–24, 14% **ages 40–49, 14%**
ages 25–29, 36% **ages 50–64, 10%**
ages 30–39, 28% **ages 65 +, 7%**

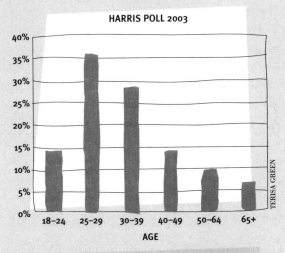

A histogram showing the distribution of ages of tattooed people in the United States according to a 2003 Harris Poll.

Q (the *Examiner*, San Francisco): But it does involve pain.
A (Lyle Tuttle, tattoo artist and lecturer): There's a good, brisk, stinging sensation, yes. I always jokingly say that it's neither entertaining nor excruciating. It's right in between.

Perhaps the best way to mitigate the pain (because by now we all agree that it does hurt) is to understand, in detail, the typical tattoo process (chapter 5). Nothing is as daunting as the unknown, but there is absolutely no reason for the tattoo experience to be unknown or even unpleasant in any of its aspects. Knowing what to expect, in what order, and how long it will last, will be the biggest ally in dealing with both natural anxiety and some amount of pain. Knowledge about the details of the tattoo process can do more than mitigate pain; it can also help to assure that your tattoo process is not only a happy one but a safe one as well.

Pop Quiz: A scratcher is:

A. Someone tattooing for money without the benefit of proper training.

B. A small wooden tool, resembling a tiny rake, used to remove dead skin from a healing tattoo.

C. A light table used in tattoo shops to trace existing designs.

D. A person whose skin has an allergic reaction to tattoo pigment.

E. The first tattoo machine, patented by Edison in 1892.

ANSWER: A is the only correct answer but if you answered B, then eleven demerit points for you. Never, never, never scratch or abrade a new tattoo in any way at all. Never.

Journey to Being Tattooed

This particular piece started over ten years ago, when I was first exposed to philosophy. Before philosophy became an academic endeavor it was treated as a personal challenge of how I was living my life. We were exposed to several different texts from a variety of cultures, including several sacred texts from Asian schools of thought. One particular image caught my eye: the conceptual image of peace. Peace was represented in a circular way with the feminine energetic aspect rising above the masculine energetic aspect that willingly recesses downward. This image is an idyllic expression of temperament, not necessarily an expression of how men and women are supposed to interact, since masculine and feminine energies (as I came to know through my studies) are present in everyone. It is this sort of balance within ourselves that helps us to turn that other cheek, to commit acts of kindness or to be unattached to what the circumstances of life lead us to lose. Well, if I was gonna have anything inked on my body at all, I could think of nothing better than that! In the Asian texts that I was studying that image of peace was most colorfully expressed by the receding dragon and the ascending phoenix (which is a markedly different kind of phoenix than the Western one). In between the twists and turns of living I set my mind to research the symbology further.

Over ten years later, I am left with only the dragon. Well, five years ago, after scouring through book after book of images and drawings, I finally found the dragon that made me stop. It was an image from one of a pair of vases from

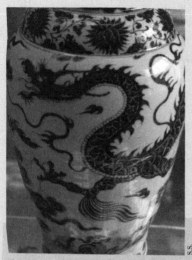
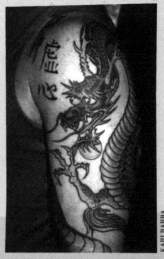

The dragon of the David Foundation vase in London.

The dragon as a tattoo, by Kari Barba.

S.S.

KARI BARBA

fourteenth-century China called the David Vases (called that because they were owned by the Percival David Foundation in London). These vases were amazing for their detail and for the fact that they were nearly identical. As it turns out, they were also significant because, since they were dated, they helped place the beginning of the use of cobalt blue in Chinese art history. In their time, they were believed to have been used in Taoist rituals for the community that they were made for. That was inspiration enough for me. I actually had to travel to London to get detailed pictures of the vase itself (which is a whole other story)! As for the phoenix, there was a certain delicious instinct in finding the dragon; I knew right away. That never happened with all the phoenixes I saw. Past a certain point I simply decided to stick with what I know in the masculine so I surrounded my dragon with the philosophic expressions from my studies that will guide and ori-

ent him and (hopefully) myself as well. Perhaps an image of the feminine will occur to me later in life (can't expect peace at 30!).

Choosing Kari as a tattoo artist was similar to choosing this dragon: When I saw her work on previous dragons, I was as stunned as when I first saw the dragon from the David Vase. The rest was about seeing if we clicked as individuals (because I spent a good amount of time not getting along with tattoo artists in the Bay Area); I love Kari and can't wait to talk to her about my latest idea . . . on a story older than this one.

—S. S. (Berkeley, CA)

Bonus Question: Is It Safe?

The answer to the question "Does it hurt?" revolves around the fact that punctures of the skin are involved in tattooing, and therein also lies the most important and yet the most unexplored question about tattooing, especially by those contemplating a tattoo for the first time: Is it safe? Opening the skin, no matter how small the puncture, exposes the body to infection. The subject of blood-borne pathogens and the risk of infection is something in which all competent tattoo artists are educated. Sterile techniques that are employed widely in the industry involve both single-use materials as well as sterilization and disinfection of equipment and the workspace. Safety, however, needs to be uppermost in your mind as you begin the process of asking questions about tattoos and educating yourself. You'll need to know what questions to ask of your tattoo

artist and what answers are acceptable. There is no reason why your tattoo experience cannot be as safe as any trip to, for example, a dentist's office—in fact, even a bit safer than that.

"Although some studies have found an association between tattooing and HCV [hepatitis C] infection in very selected populations, it is not known if these results can be generalized to the whole population. Any percutaneous exposure has the potential for transferring infectious blood and potentially transmitting blood-borne pathogens (e.g., HBV, HCV, or HIV); however, no data exist in the United States indicating that persons with exposures to tattooing alone are at increased risk for HCV infection. For example, during the past 20 years, less than 1% of persons with newly acquired hepatitis C reported to CDC's sentinel surveillance system gave a history of being tattooed. Further studies are needed to determine if these types of exposures, and the settings in which they occur, are risk factors for HCV infection in the United States. The CDC is currently conducting a large study to evaluate tattooing as a potential risk."

The Centers for Disease Control and
Prevention's "Position on Tattooing and
Viral Hepatitis C (HCV) Infection"

Health safety, tolerable amounts of pain, the enduring aspect of tattoos, and the thoughts of people who see a tattoo are just a few of the issues involved in a mindful and meaningful tattoo experience. People who want tattoos intuitively understand their importance, and that fact is reflected in the popularity of the questions above. Although the answers to those

The Permanence of Tattoos:
The Ice Man of the Alps, 3300 BCE
(otherwise known as 5,300 years ago)

In 1991, after one of the warmest summers in recent history, in the Alps between Austria and Italy (in the Oetzal region), two hikers came across a body that was beginning to emerge from the melting glacial ice. But this was no ordinary victim of a hiking accident. Instead, the thirty-five-year-old man that had emerged would turn out to be the oldest mummy ever recovered.

While the light that he sheds on the Bronze Age of Europe can (and does) fill a book, what's important here is that he is tattooed. The oldest mummy ever recovered is also the earliest known tattooed human being. That fact is, I think, no coincidence, and it speaks to the great antiquity of tattooing.

Researchers who examined the find were surprised not only at the remarkable preservation of the body and the artifacts associated with it, but also at the presence of fifty-nine separate tattoos.

"The following details have been observed so far: two parallel stripes around the left wrist; four groups of lines to the left of the lumbar spine; one group of lines to the right of the lumbar spine; a cruciform mark on the inside of the right knee; three groups of lines on the left calf; a small cruciform mark to the left of the Achilles tendon; a group of lines on the back of the right foot; a group of lines next to the right outer ankle; a group of lines above the right inner ankle" (Konrad Spindler, *The Man in the Ice*, 1994).

These tattoos mostly amount to groups of short parallel lines,

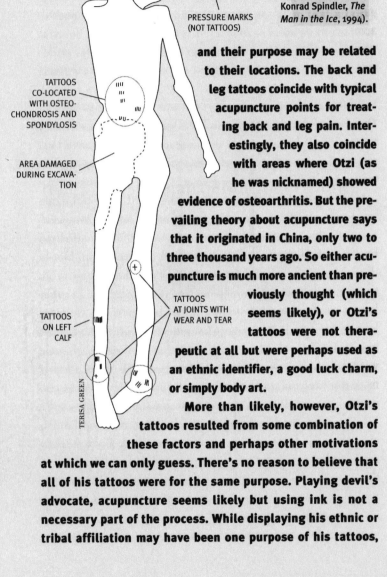

PRESSURE MARKS
(NOT TATTOOS)

TATTOOS
CO-LOCATED
WITH OSTEO-
CHONDROSIS AND
SPONDYLOSIS

AREA DAMAGED
DURING EXCAVA-
TION

TATTOOS
AT JOINTS WITH
WEAR AND TEAR

TATTOOS
ON LEFT
CALF

TERISA GREEN

The location of some of Otzi's tattoos (modified by the author from Konrad Spindler, *The Man in the Ice*, 1994).

and their purpose may be related to their locations. The back and leg tattoos coincide with typical acupuncture points for treating back and leg pain. Interestingly, they also coincide with areas where Otzi (as he was nicknamed) showed evidence of osteoarthritis. But the prevailing theory about acupuncture says that it originated in China, only two to three thousand years ago. So either acupuncture is much more ancient than previously thought (which seems likely), or Otzi's tattoos were not therapeutic at all but were perhaps used as an ethnic identifier, a good luck charm, or simply body art.

More than likely, however, Otzi's tattoos resulted from some combination of these factors and perhaps other motivations at which we can only guess. There's no reason to believe that all of his tattoos were for the same purpose. Playing devil's advocate, acupuncture seems likely but using ink is not a necessary part of the process. While displaying his ethnic or tribal affiliation may have been one purpose of his tattoos,

many of them are not easily visible given his clothing. From what we know of the artistic expression of early peoples, art is almost never art for art's sake; thus tattoos being done purely as body art seems unlikely. Many groups of people across the globe and through time have used tattooing in rites of passage from adolescence into adulthood. Since Otzi was an adult, it's even possible that his tattoos represent such a ritual.

Frankly, the speculation can go back and forth without end. The only things we really know are that Otzi is tattooed and that we'll probably never know exactly why. Even so, the fact remains that the most ancient human skin ever discovered is tattooed.

burning questions have been given, there is a whole iceberg of information that lies below them which falls logically into the chapters that follow. Each chapter is designed to build on the previous one. When you understand that tattoos are permanent, you begin to understand the importance of the design choice. When you understand what designs are tattoo-able and what you can reasonably expect from an image in the skin, you know better how to find your tattoo artist. When you understand exactly how your skin works in combination with pigment, you'll

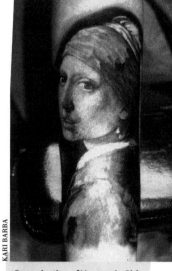

KARI BARBA

Reproduction of Vermeer's *Girl with a Pearl Earring,* by Kari Barba, Outer Limits Tattoo, Anaheim, CA.

already know what to expect from your tattoo not only in the healing process but also over its life. Tattoos are clearly not for everybody but once you've decided that you want one, your reward is the joy in the process of getting one and the lasting image that results.

2 | Your Design and How It Finds You

WITH THE HAIDAS, HOWEVER, EVERY
MARK HAS ITS MEANING . . .

JAMES SWAN,
TATTOO MARKS OF THE HAIDA, 1878

You look at the topless mermaid and she doesn't seem quite your type. Next to her is the crawling black panther, which is perhaps a bit more menacing than you feel. Maybe the red rose on the other side would be nice, or the Japanese symbol for courage just below that. Actually, the more you let your eyes wander over the flash, the more designs you realize are crammed into every nook and cranny of the sheet—not unlike some of the tattooed people in the shop there with you.

Tattoo Lingo Lesson: *"Flash" refers to the tattoo design samples that typically are displayed on posters that cover the walls of a tattoo shop. The word comes from carny lingo, when tattooers plied their trade in carnival sideshows at*

the turn of the last century. Originally, carnival flash was the collection of expensive-looking (and many times unwinnable) prizes that booths would offer. Over time, the term likely started being applied to any type of prize and even to better-looking signs. The classic tattoo font is a direct descendent of the fonts used in carnival show cards.

There seem to be tattoo images everywhere, many more than you could have imagined, and now it's becoming difficult to separate them all, let alone choose one. Finally, though, you settle on one of the designs that had attracted your attention in the first place and you point it out to the tattoo artist.

Most of the people who wander into a tattoo shop thinking that they'll get a tattoo and who don't have a design in mind will choose something from the flash. The good parts about that are: (1) flash is eminently tattoo-able (not all art makes for a good tattoo); (2) the artists in the shop probably have a lot of experience tattooing the designs displayed in their flash; and (3) you'll find yourself comfortably fitting into a tattoo lineage of sorts where you can take up your place as the latest person to get that design tattooed. The not-so-good part about choosing your design from flash: see (3) above. It's not particularly original or unique. When you're choosing something from flash, you can rest assured that somebody else (dozens, hundreds, maybe even thousands of somebody elses, depending on the design) has the identical tattoo. If that's not a big deal for you, choose away. However, if you thought that you were going to permanently mark your body with a design that was individual, one of a kind, re-

flecting something special about you, and setting you apart from the unwashed masses, then think again.

Ultimately, nothing is wrong with either scenario. It's really just a matter of what you want and how much time you want to spend in the process of getting a tattoo. In either case, though, whether you spend months creating something custom with your tattoo artist, or whether you walk right in off the sidewalk and couldn't be happier with the Japanese character for "courage," be aware of the design that you are choosing. Whether it's flash on the wall or a design right out of your own brain, you will eventually be choosing something that will be with you for the rest of your life.

Where to Start Finding Your Design

Totally lost on this one? That happens to a lot of people, so let's start with something concrete: the different categories of tattoos. Part of the decision-making process involves getting acquainted with all the options. Some of these will immediately turn you off, which is a good thing when you're trying to narrow down the choices. Others will not only seem interesting, but you'll come back to them, over and over again. We'll get to that later.

ANIMALS The most popular single category of tattoo designs is also the first alphabetically. It's been estimated that about 25 percent of all tattoos have some sort of animal involved in the design. These types of tattoos include everything from entire scenes of a wild jungle habitat to a single diminutive frog, from doves to dolphins, and alligators to zebras. At times people with an animal tattoo identify with the

look or behavior of the animal, feeling that it represents a part of them. Other times their animal symbol is a reminder of a particular place (penguins) or is simply a particularly cute (pandas) or ferocious (pythons) type of creature.

ANTISOCIAL OR HATE Don't get one of these tattoos. Neo-Nazism and white supremacy have to be so incredibly bad for your karma. What if you change your mind and start liking people? You'll feel like a total idiot then, that's what, with those SS thunderbolts on your forehead or that "100%" on your hand.

Tattoo Trivia: *The "100%" tattoo stands for 100% Caucasian.*

BIKER Being a biker and having a tattoo go hand in riding glove. Many of these tattoos celebrate the lifestyle of riding enthusiasts, involving everything from their machines and their clubs to their chicks. If you want the Harley logo, though, be sure your license says "motorcycle" on it before some tattoo artist makes you prove it.

BLACKWORK Plenty of people prefer not to have color, sticking to blacks and grays. Part of your design choice and style choice will involve whether you want color or not. Much indigenous Polynesian tattooing is done in black.

BIOMECHANICAL This style of tattooing has got to be one of the most interesting types done today, totally off-putting to some and the ultimate statement to others. Typically, the tattoo consists of an image of the skin ripped open to reveal the

How Kanji Works

Kanji is the oldest of three writing systems used in Japan today and it is ultimately the most complex. Kanji characters are borrowed from Chinese, and like Chinese they do not represent an alphabet. Instead, the complicated forms for each kanji character are small, self-contained pictorial images, just as in Egyptian hieroglyphs. Unlike Egyptian characters, however, kanji characters are composed of a number of different lines that are bound within an imaginary square, where the lines are used to suggest objects or actions rather than represent them literally. It's more than just a system of writing, however; the practice of calligraphy raised the depiction of kanji to a high art. Early Japanese emperors and Zen priests mastered the flow of spontaneous yet constrained movements of the brush that created kanji writings that were admired not only for their aesthetic value but also the spiritual effect that they induced in the mind of the reader. In tattoo symbolism, kanji characters are often done in this same spirit of artistic achievement, even going so far as to simulate brushstrokes, and even brushstrokes done in their traditional order. The choice of what to say with kanji characters runs the entire gamut from whole phrases to personal names or a single thought. When using kanji to spell a Western name, using the phonetic equivalents associated with each kanji character, be aware that in Japan the writing system of katakana is specifically used for foreign words and names, not kanji. In fact, many different kanji may be available for any given particular Western sound. The use of kanji for

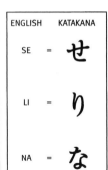

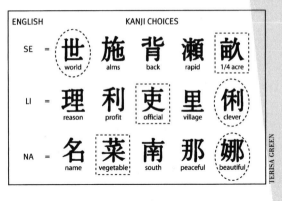

TERISA GREEN

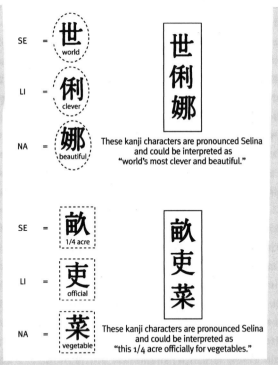

SE = 世 world

LI = 俐 clever

NA = 娜 beautiful

These kanji characters are pronounced Selina and could be interpreted as "world's most clever and beautiful."

SE = 畝 1/4 acre

LI = 吏 official

NA = 菜 vegetable

These kanji characters are pronounced Selina and could be interpreted as "this 1/4 acre officially for vegetables."

Japanese kanji characters are some of the most popular designs being done in tattooing today.

Western names does, however, have two bonuses: First, it provides a less obvious alternative to the typical "name game" (getting a tattoo of the name of your significant other) and second, the pictorial meanings of kanji provide an opportunity to add a second layer of meaning to the phonetic spelling.

inner workings of the body. Instead of bones and muscles, though, rods, pulleys, gears and tubes are revealed. It's *Alien* meets *Terminator* meets ink.

BUDDHIST Buddhist symbols are a growing group of tattoos in the West that includes everything from portraits of the Dalai Lama himself to protective Sanskrit writings of Buddhist prayers. In between are the occasional perfectly petalled lotus or the Sanskrit symbol for "om" (the primordial sound of creation and meditation, in case you were wondering).

CARTOONS After animal tattoos, this might be the next biggest category. From the Tasmanian Devil or Calvin and Hobbes to anime cuties like Battle Angel Alita or Sailor Moon, cartoons are a continuing favorite with tattooees. Easily customized (imagine Taz with a pint of beer or Hobbes with a sailor hat) and instantly recognized, there's an entire history of meaning encapsulated in these colorful little packages.

CELTIC These tattoo designs are very complicated, interwoven knot work that can be used to draw most anything that's ultrapicky and intricate. Typically, however, they feature the

same kinds of drawings historically found in the great illuminated manuscripts, such as the Book of Kells.

CHINESE OR JAPANESE CHARACTERS Another tattoo style whose popularity is on the rise is the Chinese or Japanese character that is used either to spell a Western name or capture a single thought in one ideogram ("courage," "peace," "love," "barf"). Be very careful when choosing these, however, and, if at all possible, check your choice with a native speaker or a good dictionary. There's a big difference between "mysterious" and "strange"; just ask Britney.

CHRISTIAN Always a popular choice, the religious theme is one that many people feel comfortable with and one which stands some chance of not changing during your life. Sailors used to have a cross tattooed on their backs, hoping that it would save them from a flogging. The vast majority of Christian tattoos center around cross and crucifix imagery (they're not the same, by the way—a crucifix shows Christ crucified) but this category would also include the Sacred Heart and the Virgin Mary of Guadalupe as but two classic tattoo examples.

DEATH Yes, badass skulls and crossbones are everywhere but this isn't the shallow horror movie or Goth choice that it might seem—not that those are bad things. "Memento mori" (Latin for "remember you must die") is at the heart of death imagery. While that might be depressing to some, it's actually a reminder to live life while you can.

EGYPTIAN Mostly these tattoo designs are inspired by decorations found on the walls of the tombs of ancient Egypt. If

that isn't creepy enough for you, you can spell your own name in hieroglyphs, copy some text from the Book of the Dead, or get a portrait of Tut's funeral mask. Like some Chinese and Japanese characters, hieroglyphs are ideograms and can be used to phonetically spell out words or names or to express an idea.

Tattoo Trivia: At some point in the 1960s, when bikers were feared as outlaws and criminals, the American Motorcyclist Association announced that only 1% of the riders in the country were actually outlaws. Proud to be considered part of that fringe element, then and now, bikers will still sometimes get a tattoo which simply reads "1%."

EROTIC This type of artwork finds its way into all manner of venues, and images in the skin are no exception. From Batman kissing Robin to a whip-wielding Bettie Page as your favorite dominatrix, there are whole hosts of erotic images that have made their way into tattoo artwork. Part advertising and part entertainment, this is one category of tattoos that you might not typically see in flash.

FINE ART The ceiling of the Sistine Chapel isn't the only place you'll find Michelangelo's work. From his *Creation of Adam* to a simple Mondrian, fine art appeals to tattoo devotees in terms of their skin as well as their walls.

FLORAL Millions of flowers everywhere—on the planet and in the dermis. Their enormous variety, their symbolism (from the black rose to the yellow and every color in between; with leaves or without; with thorns or not), and their beauty all

contribute to their popularity in tattoos. A single flower, a bouquet, or perhaps an armband or scroll make these designs a customizer's heaven.

GANG I've decided not to lump this with prison tattoos. Some of the differences are obvious; people in gangs haven't necessarily committed a crime . . . yet. Often their tattoos are crude since they're home done (though not always) and their symbolism centers on allegiance to their group, with a dose of violent imagery thrown in.

HINDU Although to a much lesser degree than Buddhism, the symbols of Hinduism—that is to say its gods—are gaining popularity in Western tattoos also. The elephant god Ganesha, the beautiful and blue-faced Krishna, and the multi-armed dancing Shiva are wreaking their cosmic forces in ink.

HORROR Ghouls and cemeteries, castles on moonlit nights, eek! You might also want to throw Satanism in here but that could also go under spiritual tattoo designs. One worshipper's horror is another's religion.

INSECT Perhaps not a category that springs immediately to mind when you see it called "insect," but the butterfly tattoo is probably still the most popular tattoo among women. Add to that some ladybugs, some black widows, dragonflies, and bumblebees—well, you get the idea. It's a pretty fun bunch of designs.

JAPANESE The Japanese group is both a category of tattoo symbols and a style of tattooing. In Japan, a unique style and aesthetic has been developed and refined over the course of

centuries. It's one of those types of tattooing that has several entire books devoted to it (see the "Resources" section in the appendix). These tattoos encompass natural as well as mythic themes plus creatures, warriors, and gods, all within a uniquely stylized presentation.

LETTERING Simple lettering? Oh yes. From beautiful scripted names that look like they could have come from a wedding invitation to the bold Gothic lettering of gang names, some tattoos just tell it like it is. There's a straightforward appeal in this perennially favorite type of tattoo. Names, dates, a Bible verse, and even a poem or two make their appearance here.

LUCK Good fortune is a theme in symbolic imagery that gets played out in several ways in tattoos, ranging from four-leaf clovers to dice rolled up seven and from "Lady Luck" to a horseshoe. There must be some big mojo at work when you permanently carry your "good luck piece" with you at all times, everywhere you go.

MARITIME The pendulum swings back and forth in fashion and is on the upswing when it comes to nautical/retro types of tattoos. The hula girl and the nautical star that your grandfather had are just as likely to show up on your girl-friend now.

Tattoo Trivia: Sailors used to tattoo the fingers of one hand with "HOLD" and the fingers of the other hand with "FAST" to remind themselves about their grips while swinging in the rigging.

MEMORIALS Perhaps terrible in what they recall, memorial tattoos are the most bittersweet and intensely personal of the tattoo repertoire. Pets and people and life-changing events all get recorded in the skin to act as a constant reminder.

MILITARY Tattoo culture could have faded from Western popularity had it not been for sailors and soldiers keeping the tradition alive. Tattoo shops worldwide have flash devoted to military themes, especially when they're located near military

Pilgrimage to the Holy Land

"In the old City of Jerusalem one afternoon in 1956 I discovered a collection of woodblocks which struck me as unique in character." So begins John Carswell's compellingly simple account of his discovery of the remnants of a centuries-old tradition of tattooing in the Holy Land that goes back in written records to at least the 1600s and quite possibly much earlier. In the tattoo/coffin-making shop of tattooer/coffin-maker Jacob Razzouk, Carswell recorded the designs of 168 woodblocks that were carved with various, mostly Coptic Christian, tattoo designs. The blocks and the trade had been in Razzouk's family for generations.

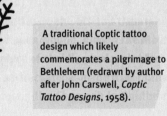

A traditional Coptic tattoo design which likely commemorates a pilgrimage to Bethlehem (redrawn by author after John Carswell, *Coptic Tattoo Designs*, 1958).

TERISA GREEN

bases. From a generic "Death Before Dishonor" to the specific insignia for particular units or branches of military service (or even particular operations or battles), many different images are fodder for this time-honored type of tattoo.

MISCELLANEOUS Where else do you stick a tattoo like the biohazard symbol or the Zig-Zag man or Nordic runes? If I tried to cover all of these here, this wouldn't be a book about how to get a tattoo—it'd just be a list of miscellaneous tattoos.

Customers looked at the blocks and picked their design. The tattooer would then use the block to stamp an ink impression on their skin, using it as a guide for tattooing. A cross of equal lengths on the inside of the right wrist or on the back of the hand, between the base of the thumb and the index finger, was not an uncommon way for pilgrims to commemorate their journey to Jerusalem. In this more elaborate example, the cross of equal lengths has a similar cross in each of its quarters, a symbol known as the Jerusalem Cross. Above it are three crowns and a star with its lowest point extending downward. Below are two branches joined by a bow. This tattoo was probably used to commemorate a pilgrimage to Bethlehem, with the three crowns standing in for the three wise men, plus the star of Bethlehem. These tattoo blocks, passed down through generations, retain the unaffected, straightforward, and distilled designs that even today manage to exert their charm. But tattooing and coffin-making? Pilgrimage tattooing peaked at Easter and the rest of the year Razzouk had to make a living somehow—no association between the two occupations apparently.

MYTH AND FANTASY From tiny fairies who perch on flower petals to fire-breathing dragons, the human imagination has produced an entire crop of symbolic images—completely imaginary, and yet we're all familiar with them.

NATIVE AMERICAN Pocahontas, although a real person, is more likely to crop up in the cartoon section (above) now that there's a Disney movie. However, other portraits of Native Americans plus a whole assortment of medicine shields, dream catchers, stone tools, and rock paintings land in this category. Ironically, people today will interpret these symbols as authentically American despite centuries of systematic attacks and repression perpetrated by the US government in order to gain Native American land and resources.

NEW SCHOOL This category is a style of tattooing if ever there was one. The colors are so intense and vibrant that it looks like really good graffiti—bold and big. Like the other styles, it can be applied to any type of symbol that you'd like to have looking all punked up, blown out, distorted, and a bit twisted.

OCCUPATIONAL OR HOBBY Some people are lucky enough to do what they love for a living, while others have to be content with being passionate about their hobbies. Our pastimes often make their way into our tattoo choices and they can be represented by a huge array of images: musical notes, comedy and tragedy masks, a Mack truck, a Cessna, even a typewriter.

OLD SCHOOL Bold black outlines, classic tattoo themes, primary colors, and darker shading than contemporary de-

signs typify this style of tattooing, which is currently undergoing a renaissance right along with nautical and retro designs. It's a style that can be applied to any type of symbol or image, though.

PACIFIC NORTHWEST These highly stylized and high-contrast images are among the few indigenous forms of tattooing that are used in much the same way that they were historically. Abstract whales and dolphins, beavers, bears, and other creatures of the Pacific Northwest coast are popular tattoo choices for people everywhere now. We could even consider this group a subset of Native American symbols but I treat it separately because of its very distinctive look.

PATRIOTIC Separate from military, memorial, and maritime tattoos is another class of tattoos that features images that are simply patriotic. National flags and the colors of those flags figure largely in these designs. But there's also the occasional Statue of Liberty, red maple leaf, or eagle killing a snake.

PINUP GIRL Did your favorite uncle ever flex his biceps and make one of these dance? Betty Grable may have been the original pinup girl, and she still appears in tattoos, but today even women will get a pinup tattoo, maybe of Betty Boop.

POLYNESIAN If you're hard core and feeling lucky about sanitization, you'll actually go to one of the Polynesian islands and get one of these done in traditional fashion. Mostly black, the tattoos are composed of arrangements of geometric shapes done in small and large patterns, depending on

the body location. The traditional method of tattooing in these parts of the world involves tapping a sharp group of needles (which looks like a tiny rake) into the skin—not for the faint of heart or those without airfare. However, Western practitioners of the style will use sterile and modern equipment, adapting traditional designs with an updated aesthetic.

PORTRAIT Portrait tattoos aren't always memorial tattoos. Weird Al Yankovic and the Dalai Lama aren't dead yet. Nor are many of the celebrities whom you can see tattooed in the skins of their biggest fans.

PRISON It's a fact of life that people make mistakes, like getting caught when they commit a crime. While prison tattoos and gang tattoos may seem a lot alike at first glance, prison tattoos can sometimes be of very high quality. Not surprisingly the designs tend to dwell on the time being done and the crime that was committed. There's also a sense of trying to create some modicum of individuality in such a homogeneous and artificial culture, but many tattoos are also hate-related, with racial themes.

RELIGIOUS Sorry, splinter groups, if you're not one of the main five, you're here. Rastafarians, Wiccans, and practitioners of Voudou have all inked their skin with their symbols. No less powerful, just less common.

TRIBAL The thing about tribal tattooing is there is no tribe—not one tribe anyway. Tribal is more a black graphic style of solid pointy curves that are generally abstract but inspired by ethnographic designs from Polynesia. It's a style

that can be used in armbands, symmetric scrolls on the lower back, or even a facial portrait of Jesus.

ZODIAC Two flavors of the zodiac can be had: the monthly variety of the West, running from Aquarius to Capricorn, or the yearly variety of the East, running from the Year of the Rat to the Year of the Dragon. Be careful on the yearly variety though; people might be able to guess your age.

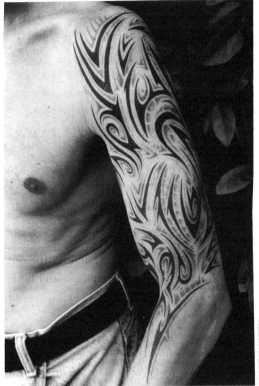

Polynesian-inspired tattoo work by Leo Zulueta, Spiral Tattoo, Ann Arbor, MI.

Always and Forever

You know from chapter 1 that a tattoo is forever, and you'll find out in chapter 4 exactly why that is so. The permanence of your tattoo choice is your number one, top of all time, most important, never forget this, make it a mantra consideration when choosing a tattoo design. Never get a tattoo thinking that you'll be able to change it, since you very well may not without some scarring. Always think of your choice in terms of living with it for your entire life. It must stand the test of time, of fashion, of trend, of what is likely and unlikely to change about you and your life should you hopefully live to be a hundred. Imagine your tattoo choice when you're forty, or when you're applying for a job, or when you have kids, or when you're at the beach, or when you have grandkids, or when you're at the gym, or when you meet the love of your life.

If that gives you pause, it should. There is simply nothing more important to visualize when you're choosing your tattoo design and body placement than the years rolling by. I'm not talking about how the tattoo physically changes with time. That's chapter 6. I'm talking about seeing your design choice, day in and day out, for the rest of your life. As only one example, if your tattoo will be easily visible in a short-sleeved shirt, located perhaps on your forearm, imagine listening to strangers ask you about it and having a conversation about it . . . every day, maybe twice a day. Rest assured that the only other time in this book that I am so shrill is when it comes to understanding the possibility of infection. Honestly, I save this tone of voice only for the really important stuff. So don't skip visualizing your tattoo on your body at different stages of your life—it's a very important step.

I Got Mine from a Children's Book

One of the most enduring and powerful tattoo symbols of the twentieth century has a history which few tattoo devotees would suspect. The "black panther" or "crawling panther" is a form of the big cat whose contours make it ideal for placement over rolling and fluid musculature of the human body, primarily on arms and legs. Tattoo artist Amund Dietzel must have recognized that primal appeal when he adapted it for tattooing. Known as "the master in Milwaukee," Dietzel was reportedly only ten years old when he joined the Danish Merchant Marines, learning the craft of hand tattooing while still only a young teenager. In 1907, at the age of seventeen, he was shipwrecked in the Saint Lawrence Seaway and ended up staying in the US, tattooing in different cities of the Northeast and northern Midwest, as well as touring with carnivals and circuses and visiting tattoo parlors around the country, until he established his own tattoo studio in Milwaukee in 1916. In 1934, a children's book was published by Grosset & Dunlap

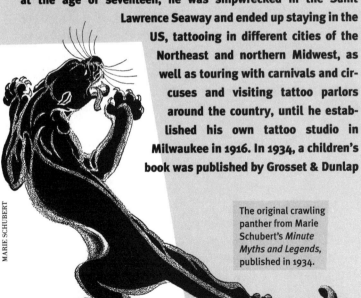

MARIE SCHUBERT

The original crawling panther from Marie Schubert's *Minute Myths and Legends*, published in 1934.

Amund Dietzel (1890–1973), also known as "The Master in Milwaukee."

called *Minute Myths and Legends: Dramatic Moments in the Affairs of the Gods, Arch-Demons, Goddesses, Demi-Gods and Heroes of This and Other Worlds* with illustrations by Marie Schubert. The crawling panther made its debut as the monstrous and magic cat sent to devour the mythic Irish hero Cuchulain (who thumped it on the nose with the flat of his sword and then tossed it bones while he finished his dinner). Dietzel reportedly adapted Schubert's design and the rest is tattoo history. You just never know where your tattoo symbol might have been born.

Bubble Up

Some people have their symbol from the time they're three and that's that. Let's say, for the sake of argument, that it's the phoenix—the bird of Greek myth which is able to rise from its own ashes, a powerful symbol of rebirth and triumph over seeming defeat. For these people, they have

waited all their young lives to be of tattoo-able age and always envisioned some sort of phoenix as their tattoo symbol. Or they have gathered phoenix symbols around them for the first fifty years of their life and have come to some point where a tattoo is an attractive thought. There is no question in their mind that the phoenix, in some form, is going to be the image that they choose. These people are enviable, and also pretty rare.

The rest of us are going to have to think about our symbol consciously and subconsciously. If you want a tattoo but don't know what you want, it's not likely going to come to you because you decide to sit down one day and reason it out. Instead, it's going to amount to a combination of reasoning and looking and having it in the back of your mind so that when you see it, you'll gravitate to it . . . or them. There's nothing to say that you won't want more than one or that you can't combine multiple images into one custom design. Take some of the pressure off yourself and realize that the "choice" you make is eventually going to come from you, from somewhere inside. You'll do your research, of course, and peruse every type of tattoo resource that exists. You'll consider all types of artwork, tattoo and non-, from which to draw inspiration. But one of the ways in which your design makes that journey from your inside to your outside manifests itself as your returning, in your research, to the same thing over and over.

You will find that certain of the tattoo categories listed above resonate with you while others leave you cold, which means that you've already started narrowing the choices. The same is true of the different styles. You'll eventually end up looking at the same photographs in this book repeatedly while completely ignoring others. You'll find images that

please you and others that seem ridiculous. Although the huge array of choices at first seemed like a mess, your mind has begun to pigeonhole them, sorting them in whatever way seems to make the most sense for you—perhaps by geography, by antiquity, by subject matter, by color, or even by size, to name a few. A next possible step in beginning to narrow your choices is understanding the actual meaning and history behind the designs. Often there is information in symbol meanings that helps to sway a potential tattooee in favor of one tattoo over another. It is the next layer in the tattoo design onion.

For example, many different flowers have a beauty in form and color that makes them ideal for someone in search of a delicate design, perhaps even something that is almost photorealistic in its detail. How does one choose among so many flowers, though? Many people have their favorite flowers, so that helps to narrow the choices. However, many flowers have a symbolic meaning behind them that may not be obvious but whose knowledge would help in the tattoo decision-making process. In fact, without even knowing it, you may be vaguely aware of some of these meanings. Ever heard someone say that something was "as fresh as a daisy"? We seem to know intuitively that the daisy is not a flower of romance (not typically presented to your prom date) or mourning (not typically sent to a funeral). It's a flower of youth and spring, from the Old English for "day's eye." In addition, people have also used daisies to predict their luck in love by picking the petals. It is a flower symbol that seems to represent new potential, in different but related arenas. Is this your flower design then, a perfect combination of meaning and image? Or perhaps it's just that you know someone named Daisy.

However it is that you come to that narrowing of the choices, along the way try to ask yourself at various points what's important to you. Your answer to that question doesn't have to be an epiphany or a spiritual awakening or a Zen moment. Instead, it may help to steer your design choice path into territory that is a little less explored and so a little more unique. Surprisingly, while many tattooed people will ascribe this kind of meaning to their tattoo after the fact, very few make the effort beforehand. By at least attempting to consciously pick a tattoo symbol that you can live with for the rest of your life, you're already part of an exclusive group.

To Color or Not to Color

Not all tattoos use color, as is obvious when looking at the tribal or black graphic style of tattooing. However, the preference for black and gray alone far exceeds this one style of tattoos. From brushlike re-creations of Japanese *sumi* paintings to simple lettering, many of the categories of tattoos above lend themselves to a strictly black and gray treatment. Portraits are often done with black and gray, like a reproduction of a black-and-white photo. Even flowers, animals, and reproductions of statues such as Michelangelo's *David* have been done with startlingly real representations without color. Why not use color? It's strictly a personal preference when it comes to considering your design choice. Black tattoo ink of various types and compositions has been around for thousands of years and, simply through sheer accumulation of experience, it's probably the safest color in terms of allergic reactions

(more on this in chapter 4). However, when people choose blackwork over color, this is rarely the reasoning that they have in mind. Instead, it's an individual inclination which some people find more artistic, serious, and attractive, going so far as to have all their tattoos in black and gray, eschewing color with disdain. Others might view blackwork as dull and not eye-catching enough for their tastes. In either case, make the color of your tattoo as much a part of your visualization process as possible, since you do get to make a choice here.

Tattoo Like an Egyptian

By the time of the ancient Egyptian New Kingdom, 1550 BCE, tattooing had been a part of the culture for centuries—for women, that is, since tattoos have never been found on the men. In the New Kingdom, however, tattoos were dramatically transformed. Although still done only on women, the abstract geometric patterns of dots and dashes gave way to actual representations. And what better image for the ancient Egyptians than a god—the god Bes. Not the most famous of Egyptian gods,

The upper image is illustrated from a gold figure of the ancient Egyptian god Bes, while the lower is a tattoo image used during the New Kingdom. Illustrated by Greg James.

Sumi, also called *Sumi-e* (and pronounced soo-mee-ay), is a monochromatic style of Japanese ink painting created with black ink strokes and gray washes. Anything extraneous in the composition is eliminated, distilling the image down to the essential character of the subject. Tattoo by Robert Benedetti, owner of Sunset Strip Tattoo, Hollywood, CA.

Bes was a curious little deity thought by some to be derived from a lion type of god of the Predynastic Period. Shown as a bearded, savage-looking yet comical dwarf, he had a large head, pointed ears, a protruding tongue, bowlegs, and sometimes an erect penis. Initially revered as a household deity who guarded against evil spirits and misfortune and presided over childbirth, over time he also came to be known for bringing pleasure to merrymakers and as a symbol of sexual potency. An abstract image of Bes tattooed in the time-honored dot-and-dash method was found on a Nubian mummy at Aksha, datable to the fourth century BCE. As a result of that find, we can interpret the images of Bes shown in Egyptian artwork on the thighs of dancers or musicians as tattoos. Although the images are highly schematic and look more like stick figures, they do indeed have the characteristics that had long been associated with Bes. The first known representational tattoo is thus an Egyptian god, and a fun-loving one at that.

Where Do You Find This Stuff

IN PRINT Images of tattoos are everywhere, until you want to see them, of course. Any newsstand will have at least one tattoo magazine but probably many more. Get to a newsstand and get some magazines, including *Rolling Stone*. Get to a bookstore and leaf through some of the glossy coffee table books about tattoos. Some of the best photos of tattoos are in these kinds of books. The whole subject is, after all, pretty photogenic. Get on the Internet and start surfing. In the appendix are URLs for some of the major (and more stable) tattoo and body art Web sites. If you do a search for tattoos with one of the search engines, you're going to find millions of Web pages, most of which have to do with tattoos and many of which are R-rated, so beware. For tattoos in the flesh, though, you can't beat three places: a tattoo convention, a tattoo shop, and an NBA game.

IN THE FLESH It comes as a surprise to many people outside the industry that there are such things as tattoo conventions. Virtually all the major metropolitan areas of the world host at least one tattoo convention each year. For the latest information on their dates and locations, Web sites are the best bet. Studios, artists, and retailers rent booth space and try to sell you either goods or services. Tattooing and piercing go on at some of the booths and there are usually tattoo competitions as well, with neat trophies and everything. In addition to attracting a great many tattooed people, who know that their tattoos are going to be stared at, conventions also draw artists who will often display their portfolios on the table at the front of the booth. These amount to photo books of various sizes, generally with four-by-six or five-by-seven prints that you can peruse. Nowhere will you come into con-

tact with so many photographs or actual tattoos as at a convention. There's also a helluva lot of nice people at these gatherings. We'll cover these events and their associated etiquette in more detail in chapter 3.

IN THE BUSINESS The next best thing, although it's a far cry from the density at the large conventions, is visiting tattoo shops. There may be only a couple of tattooed people (the artists, let's say, hopefully anyway) or people getting tattoos (which you can generally see if they're sitting in a chair in the front). The added bonus at the shop, though, is flash and the shop itself, which in all likelihood might be one of the places you'll end up being tattooed (unless you have some place or some artist specifically in mind for which you are willing to travel). Generally flash covers the walls but it can also be arranged in poster displays that you can flip through like an enormous metal book. You can also get a little bit of question and answer time if the artists aren't busy tattooing people.

As for the symbolic and historic meaning behind the designs that get used in tattoos, books are your best bet. You can begin with symbol dictionaries but pretty quickly you'll be branching out to books on the world religions, Greek mythology, Tarot guides, astrology books, and all types of very specialized tomes ranging from Tibetan Buddhist symbols to Nordic runes and volumes about the Vikings, Japanese art history and Egyptian hieroglyphs. The research paths are endless both for the actual images and the meanings behind those images. Information about symbol meanings on the Internet is often copied from one place to the next and is not always accurate. Many times it's a combination of some facts, some folk wisdom, and much repetition (*much* repetition).

Weighing Options

At this point, you may have done your job too well and come up with too many nifty ideas. Maybe you just adore Monet and you've got twenty paintings selected for reproduction in your skin. Or you want a whole garden of flowers, or one zodiac symbol for each of your three kids. Although many people like to use their gut feelings to make decisions, it doesn't necessarily end up being the best method, although it's the quickest and easiest. Another way to approach your decision-making process is to rank your choices, perhaps with a numbered list of sorts, but this sounds more like how to pick a good stock on Wall Street than a tattoo. Still another way to settle on your design would be to ask yourself a couple of questions: If you could get only one tattoo (which might easily be the case depending on how your skin and you and your wallet react to the whole thing), what would you get? Assume that, for the rest of your life, you could have only that one tattoo. What tattoo could you simply not live without? These types of questions help you to put your choices in perspective and hopefully narrow them down to one.

Curves

Part of the beauty of a tattoo is the way it fits the body area on which it appears. So part of the design choice also involves considering body placement. If you were to trace a very loose outline around many tattoo designs, you'd find that they are vaguely egg-shaped, more or less, which ends up being a

Itsy-Bitsy

One of the more common regrets that people have as they look back on their first tattoo is having made it too small. It's natural to be conservative and play it safe, especially if you've never had a tattoo before—and there's something to be said for that, especially if you suspect that your skin may not react well to a tattoo or if you know that you have a particularly low tolerance for pain. For the vast majority of people, however, the tendency to make that first tattoo small results in its being *too* small. What's too small? The smaller the design, the less detail it can accommodate. While a single Japanese letter or a simple red heart may look just fine when it's only one-by-one inch, you'll never see a Celtic cross or a clipper ship even close to that size. A detailed design requires more space, and the more detail desired, the larger the tattoo should be. Given that many tattoos receive some amount of sun over their lifetime, the pigments will begin to break down and move on a molecular level. On large, bold designs, that aging process results in a softening of the image that is not altogether unpleasing. On a small and finely detailed design, however, the result is the growing together of lines that used to be close and the blurring and fading of lines that were very thin. Also, body placement has something to do with the optimum size of a tattoo. A delicate little design may create a pleasing composition when located on an ankle but might be lost in a sea of blank skin if done, say, on the upper arm, especially the upper arm of a bodybuilder. Consult with your tattoo artist and weigh his or her advice

carefully. Your artist is as interested in creating a tattoo that's right for you as you are and has seen many different types of tattoos on many different body types, sizes, and locations. Remember, as you make your decision, that a fairly common regret on a first tattoo is to have erred on the side of conservatism and gotten a tattoo which ultimately seems too small.

very beautiful shape on curving contours of skin. Because the body is curved, squares don't lie easily on it. Straight edges can sometimes be difficult to achieve. Rounded, flowing, and curved design forms, however, can be enhanced by the curves of the body, be they hardened muscles or plumper parts. In order for a design to fit a body spot perfectly, there is a combination of overall shape and size about which your tattoo artist might be able to offer some advice.

For example, while the pierced heart (the heart with an arrow through it) has an overall rounded shape and you've decided that you want it on your upper arm, it ought to be big enough so that it doesn't get lost on the large part of the arm, but not so big that you couldn't see the outer edges. It could be centered on the middle part of the upper arm (the bulge known as the biceps) or the area closer to the shoulder (the deltoid). An armband, on the other hand, could easily be placed on the narrowing of the arm between these two muscled areas. How thick an armband design might be depends somewhat on the size of your arm and of course your own artistic likes and dislikes. As you consider and visualize your tattoo, you may play with some of the details in order to create the best effect for the part of the body that you choose.

In rare cases, the design and body placement are completely inseparable. A pair of red lips on the derriere as a visual pun for "kiss my ass" or the gallows humor of "Cut Along the Dotted Line" with a dashed line tattooed onto a scar are examples of these types of placements. Most of the photos of tattoos in this book have been cropped so as to show the tattoo itself in as much detail as possible. A few, however, also manage to show how the tattoo fits the body placement.

The Don'ts

All of that stuff above is about what you can and should do when you're picking your tattoo design. The cautionary and parting words in this chapter are the list of don'ts.

✝ **Don't limit yourself—not in the beginning anyway.** Later, when you're running out of skin, limit yourself. In this phase of getting a tattoo, however, be it your first or your fifth, let your mind wander and ponder every possibility that presents itself before narrowing your choices.

✝ **Don't let somebody else pick your design.** Let your next truck, wedding dress, or cell phone be a group choice, but not your tattoo. There's only one person that it has to satisfy. To be a good design choice, it has to satisfy that person. This isn't to say you won't talk to people about it and hear their input and their opinions, but you are in control—unless of course you're one of those actors in *The Lord of the Rings* who all got the same tattoo, or your fraternity demands it, or your combat unit is shipping out tomorrow and they bully you into it. Then it's OK.

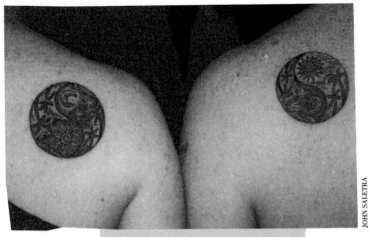

A variation on the yin-yang symbol as well as the name game, by John Saletra, Tabu Tattoo, Venice, CA.

✝ **Don't let the tattoo artist pick it.** That's just weak.

✝ **Don't pick a design that you don't understand**—really understand, including runes or kanji or Sanskrit. Do your research instead of letting something get lost in translation.

✝ **Don't get your significant other's name.** Pay for a billboard on Valentine's Day, have your marriage proposal done on the side of a blimp, bring him or her breakfast in bed every day for ten years but never have your boyfriend's, girlfriend's, or spouse's name tattooed. It is the number one reason why people regret their tattoo later.

✝ **Don't do it to please somebody else**—not even a hot-looking tattooist.

3 | Your Artist and How to Find Him/Her

MANY COME HITHER FROM UPPER INDIA TO HAVE THEIR BODIES
PAINTED WITH THE NEEDLE IN THE WAY WE HAVE ELSEWHERE DESCRIBED,
THERE BEING MANY ADEPTS AT THIS CRAFT IN THE CITY.

MARCO POLO,
THE TRAVELS OF MARCO POLO, VOLUME 2, CA 1295,
REFERRING TO A GREAT CHINESE PORT CITY HE CALLED ZAYTON

Old School tattooists, who learned their craft in the secretive and mysterious apprenticeships of the past, are sometimes loath to call themselves artists, eschewing both modern parlance and stereotypes. Nevertheless, art is precisely what they create, although their medium is ink and skin. Like all artists, they have their own likes and dislikes, eventually evolving their own styles and even specialties. Once a design and body placement have been selected, the chosen artist needs to be proficient in the style and size of your choice. If, for example, you envision a delicate Celtic knot work design on the lower back or want a nearly full-coverage traditional Japanese back piece, you'll often find that tattoo artists prefer one type of work over the other. It is said in the tattoo industry that the best advertisement is a good tattoo, and it's also

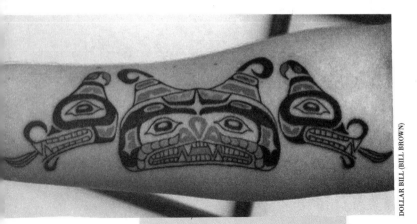

Pacific Northwest design by Dollar Bill, Sunset Strip Tattoo, Hollywood, CA.

the best place to start your search for an artist. One place to see large numbers of tattoos, in person, is at an event of which people outside the body art industry are not much aware: the tattoo convention. This chapter highlights venues for becoming aware of tattoo artists, describes how an artist should be approached, and explains how much money you should expect to pay (and how much to tip—yes, tip).

Ask and Tell

You undoubtedly know someone with a tattoo—it's a statistical inevitability unless you live in a fallout shelter, because at least one out of ten people in the United States is tattooed. If you're reading this book, then that percentage might even go up since you've probably already decided that you want one and part of that decision sometimes involves having come into contact with tattoos. When you spied a tattoo before you were

interested in having one yourself, you might have just glanced and tried not to stare. Now, however, you need to get nosey. "Where did you get your tattoo done?" you venture, to get the ball rolling. Some tattoo customers might not remember the name of their tattoo artist, but they'll almost always be able to tell you where it was done, the studio's name or where it was located. "Nice place?" you say, now that the conversation is flowing so smoothly. Of course, "nice" is different things to different people but at least you'll be able to learn how they felt about the shop and, hopefully, their tattoo artist. You might even mention that you're looking for a tattooist. The best way to find a tattoo artist is through a personal recommendation, especially if it's a glowing one. But the search for the right artist might not be quick, depending on the design and the style you've chosen. You might need to search a little further afield to locate an artist who can make your dream a reality. The beginning, however, is seeing a great tattoo.

Tattoo Trivia: King Harold II of England (ca 1020–66), brother-in-law of Edward the Confessor, was tattooed. After the battle of Hastings in 1066, King Harold's body was reportedly identified by a tattoo over his heart which read "Edith."

What You're Looking for in the Perfect Tattoo

When you're looking at tattoos in order to settle on a style or a symbol choice, also look at their quality. Assuming the healing process is complete (no redness or swelling, no peeling—these

are normal in the healing of a new tattoo but they make it hard to judge the quality), then you can look for some specific artistic things. Are the lines of the outline or the lettering smooth and clean, and of a consistent thickness? A clean solid line would be an example of good quality. Are the lines jagged, wobbly, and broken? Those lines, unless done for some effect, would most definitely be bad. More things to consider: Do lines that join one another actually meet up without a gap? Do lines that join one another stop at the right spot, without overshooting? Does the shading, be it black, gray, or color, stay within the outline—in other words, can the artist color inside the lines? Is the shading, be it solid or graduating from light to dark or one color to the next, smooth and without holidays?

Tattoo Lingo Lesson: holiday—a gap in the color of a tattoo. These can occur for a bunch of different reasons. Sometimes ink never reached that spot at all. It simply got missed by the tattooist in the midst of all the other color, ink, swelling, redness, and fluid on the surface of the tattoo. A small holiday can sometimes be difficult to see. The more common way for a holiday to happen is in the healing process. If lubricants used on the healing tattoo cause an allergic reaction or clog pores to prevent healing, small holidays may appear throughout the tattoo. Or, when the tattoo scabs or peels, it may lose some color when the scab or skin falls off.

Another thing to consider is whether the proportion and composition of the tattoo are appealing. Does it appear distorted or ill-proportioned in some way? How does it look in

Tattoo Trends

Something that humans have likely been doing since the Pale-olithic era and which has occurred in virtually all spots on the globe is difficult to describe as "trendy." The Ice Man of the Alps (see chapter 1) is just the tip of the tattooed mummy ice-berg. Where there have been people, there have been tattoos. From the archaeological perspective, tattoos are always and everywhere present, simply in the background or acting as an undercurrent. At times, their prevalence in the population may rise or fall, as permitted by the circumstances of the culture. Today in the West, the popularity of tattoos seems to continu-ally be rising. But is there another culture that we can look at

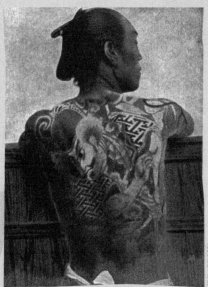

Japanese tattooing, ca 1890 (from *John L. Stoddard's Lectures, Volume 3*, 1898).

CLIPART.COM

historically where something similar happened that might help us to explain what is happening today?

While the cultures are not exactly the same, since cultures never are, we can find a historical burgeoning of tattooing in feudal Japan of the 1700s. Although the practice of tattooing was very likely thousands of years old in Japan, having been brought over from China, the social circumstances were perfectly primed when an artistic spark landed. As the lower classes began to gain power, striving against the militaristic, central, and strict authority of the shogun, they also began to develop their own separate culture and forms of expression. These new classes of society began emphasizing popular forms of entertainment, favoring them over traditional Confucian-themed works that emphasized morals and ethics. As this culture of the lower classes flourished and took pride in its own accomplishments, the artistic spark of a popular illustrated novel (known as *The Suikoden* or *Water Margin*) with folk heroes who were tattooed and who took up the causes of the common people was published. Imitating these celebrated fictional tattooed heroes, various working-class people began to have themselves tattooed. By 1830 in Edo there are records of formal gatherings of tattoo enthusiasts.

In the twentieth and twenty-first centuries of Western culture in general, there is no single work, person, or incident that might have sparked a resurgence of interest in tattoos, elevating them to the status of fashion and fad, permitting them to rise up from the ever-present background and undercurrent where tattooing never really goes away. Instead, one public or popular figure who is tattooed leads to another—perhaps a counterculture statement (which is where modern Western tattooing has many roots) that grows from something perceived as hip and desirable into mainstream culture.

Also, as tattooing was moving from the fringes of Western cultures to the mainstream, the mainstream was also widening in terms of its stereotypes and preconceptions, expanding outward to eventually embrace tattooing. Today the question is often phrased: Why are tattoos so popular now? But the question really ought to be: How have tattoos remained so popular for so long?

relationship to the body placement? Remember, of course, that some of these composition, size, and location issues are not always under the control of the artist.

Person to Person

The best way to meet a good tattooist is through the recommendation of a happy customer. If you have been so bold as to look at someone's tattoo, and you liked the quality, you will also have asked them where they had it done. Listen to their recommendation carefully. Are they happy with the tattoo? Were they pleased with how they were treated? Is there a particular artist at the shop whom they want to recommend, or just the shop in general? Just as important but way more icky—is there someone or someplace that they would definitely *not* recommend?

Tattoo Etiquette: Never dis someone else's tattoo. It's a tattoo, for crying out loud, and it can't be undone. Try to find something positive to say about the colors chosen or maybe about the body placement. If you can't say

anything nice about the symbolism, the quality, or anything at all, then keep it shut. You don't have to agree with their choice of tattoo or artist.

The Digital Age

The standard advice on where to find tattoo designs and artists used to be magazines and books. Today, it's the Internet. Assuming there is no personal recommendation on which a potential tattooee can rely, then the Web is where most people turn. This is not to say that magazines and books aren't a great way to find artists as well. Many times the book's author has found artists whom they already know and used their works as examples. These artists, if you like their style and their work, would be a fine place to start. Being in a magazine or a book ought to put a tattoo artist one step ahead of the pack, since authors and editors want to put their best foot forward and feature the best-looking product that they can. Even so, many great tattooists have never seen their work published, and if their work hasn't appeared in print it doesn't mean they're not fantastic. But as long as there's a photo of a tattoo and the name of an artist in a magazine or book, then study it closely and take your time. If you like what you see, you've started narrowing choices, assuming they're in your town or attending a convention near you, or you are willing to travel.

I found my tattoo artist through the Internet—but through the rec.bodyarts newsgroup, not a Web site. I asked a simple question: In Los Angeles, is there anybody who specializes in large, custom, Japanese work? Specifying "in Los Angeles" is important because a newsgroup can be international. I re-

ceived feedback from three people (in Northern California, Las Vegas, and New York) who all recommended the same artist. I called him, made an appointment, and went to see him, his portfolio, and the studio. I also looked at the studio's Web site online. Because tattooing and the Web are both such visual and hip mediums, it's a natural for tattoo studios and artists to have Web sites where you can see photos of their work online and also find a way to contact them. Some people will develop their custom design via e-mail, using snail mail, or just plain describing what they want over the phone.

Grand Tour

Some people travel internationally to be tattooed by the tattoo artist of their dreams. That artist is likely a world-class tattooist, someone who ranks in the top dozen or so of tattooists on the planet. By and large, though, most people don't have the money for airfare plus their tattoo. In your search for the tattoo artist best suited to you and your design, you don't want to rule out the world-class artists but you should realistically keep in mind your time and budget. In other words, drive around your town. More than likely, you're going to get your tattoo in the city where you live. Visiting the different shops in your area is a great way to meet some of the artists, possibly even seeing them at work if they're tattooing in the front chair of the shop. If you've already received a personal recommendation, consider making an appointment with that artist in advance. The work schedule of most tattoo artists is somewhat variable. Just dropping in may mean that you miss meeting someone specific or that you catch him or her at a less than

convenient time—like while putting the finishing touches on Bettie Page's face or having just started with a nervous new client. Be polite and respect his or her time and business environment. Someone will eventually ask if you need help, since they do want your business. To begin your grand tour of the local tattoo studios, since you should visit more than one even if you have a recommendation, you can find these establishments in the Yellow Pages under "Tattooing" (how's that for mainstream?) or in business directories on the Net. It's been estimated that there are some fifteen thousand tattoo shops nationwide.

Can You Have Glow-in-the-Dark Tattoos?

Yeah, but don't. It may look cool at the club but you may be risking your health. There are two ways that something can glow in the dark (other than the very rare organisms that emit their own light): It can either phosphoresce or fluoresce. We've all seen both. In the case of phosphorescence, you "charge" the phosphor in light which it absorbs and then later emits. The charge may last ten minutes to all night, and then the phosphor fades away until it has to be charged again—small plastic toys that we had as kids are examples of this. In the case of fluorescence, the light is emitted instantaneously and briefly; in order for something to fluoresce it has to be receiving radiation constantly—black light pigments are an example of this, where the black light pigment has to be in the presence of radiation. Of course, since you can only see phosphorescence or fluorescence in almost complete darkness,

Pop Quiz: Which of the following people is (or was) not tattooed?

1. **Christina Ricci**
2. **Madonna**
3. **George Shultz**
4. **Ben Affleck**
5. **Lady Churchill**

ANSWER: Madonna. Lady Churchill (Winston Churchill's mother, Jenny Jerome) had a snake encircling her wrist; former secretary of state George Shultz has a tiger on his butt in honor of his

black light bulbs are coated black but emit in the ultraviolet band (UVB), which you can't see but which gets the fluorescent ink glowing. Many, though not all, phosphorescent and fluorescent substances are toxic or carcinogenic or both. Many people who have had either phosphorescent or fluorescent pigment used for a tattoo have reported problems: itching (sometimes extreme), puffiness, the noncolor ink turning to brown, fading of the glowing effect, and dermatitis. Sometimes these symptoms don't show up until the tattoo is exposed to sunlight, and sometimes the symptoms are just delayed. Conversely, some people have reported no problems after several years. But with the use of tattoo pigments, only time tells, since they are not regulated or approved for use. To place in your skin a substance that has very little tattooing history behind it and that you know absorbs and then re-emits radiation (albeit small amounts) seems like a risk that no amount of cool at the club ought to be worth.

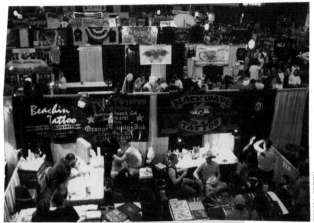

The Inkslingers Ball at the Hollywood Palladium, Hollywood, CA, 2001.

alma mater, Princeton; actor Ben Affleck has a half dozen tattoos including a large cross on his shoulder; actress Christina Ricci has a lion on her shoulder, a bat at the bikini line, and a bouquet of sweet peas on her lower back.

Convention Connections

A great place to see a high density of artists from different shops and from various places in the world is at a tattoo convention. Here the specialization in different styles of tattooing becomes more apparent as they try to set themselves apart from the other artists. If the convention is near you, then you might be able to schedule with one of those world-class artists and save the airfare. Conventions are generally an annual event. If the artist of your dreams is at the convention one year, there's no guarantee that he or she will be there the fol-

lowing year. If artists *are* going to be at the convention, there's no guarantee that they'll necessarily be tattooing. The best way to get a feeling for that is to call and speak directly to the artists (at their tattoo shops) and see what they're planning.

Many times, a convention is dominated by local studios—people who only have to travel, say, within the state to attend. Some tattoo clients may find their tattoo artist at the convention and choose to get their tattoo that very day, no appointment, no waiting. Then again, if your artist is in your state or city, making an appointment for later is always an option. Most conventions have a Web site that lists all the relevant information, including who's going to be there, the dates, the cost, and any contests or special rules. But, in case they don't, you can probably call the convention information line to get the latest. In any case, the following are some things of which to be aware when visiting a convention:

✝ Conventions are generally scheduled over a weekend, maybe beginning with some sort of social event on Friday evening, or perhaps something just for people in the industry. The main event and the major attendance will take place on Saturday and Sunday.

✝ They're not free. Purchasing tickets in advance is almost always cheaper than getting them at the door. If you do buy at the door, the price for a day pass is about twenty dollars. There are also usually price breaks if you plan on attending every day. There may be package deals that include a discount on hotel rooms too.

✝ If you've got your design and you've settled on your artist and he or she is going to be at a convention, book time in advance. This is the only way to make sure that you can have your tattoo done there. Well-known artists could

easily be completely booked for the entire convention, tattooing away in their booths. Artists might also attend as judges or panelists or in some other participatory category that doesn't involve tattooing.

✝ If you're there doing your research, talk to the artists when they're not tattooing. If *you* were being tattooed, would you want your artist interrupted? As an addendum to that, ask before you photograph anything—especially artists at work. It can be very distracting. Even if you want to photograph convention show attendees and their fantastic ink, ask first. Most people are more than happy to oblige, but you never know. Look at flash and artist portfolios but don't photograph them. It's considered poor form since the artists or attendees don't know who you are and they've put a lot of time and effort into their work. Politeness goes a long way. Maybe someone else at the booth can answer your questions or tell you when to come back if the tattoo artist is busy.

✝ Stick around for the contest results. Many times there are several contests at a tattoo convention: best tattoo done at the con that day, best overall male, best overall female, best portrait, best black and gray, best color, etc. See if any of the artists judged best by their colleagues are people you might want to have your tattoo done by. Realize too, however, that as with the Academy Awards, there's no such thing as an objective contest, especially when it comes to art. Sometimes the beauty of the canvas can be a significant contributing factor.

Whether you visit a tattoo shop or a booth at a convention, one of the things you want to see is a clean and well-lit environment—specifically, that the materials used in the tattooing process are sanitary. Everything that comes into contact with

Tattooed Royalty

Czar Nicholas II of Russia (1868–1918), the last Russian emperor (1895–1917), had "some marvelous tattoos" which had been done by Hori Chyo in Japan and Tom Riley, according to George Burchett (1872–1953). With his wife, Alexandra, and their children, he was killed by the Bolsheviks after the October Revolution.

King Alfonso XIII of Spain (1886–1941) had a tattoo of a fly sitting on an anchor, tattooed by George Burchett.

King Edward VII of England (1841–1910), the eldest son of Queen Victoria, had, according to George Burchett, "many fine tattoos" done by English tattooists Tom Riley and Sutherland Macdonald (who were at the top of their careers when Burchett was only beginning). King Edward also had a Jerusalem Cross on his forearm (tattooed by Francois Souwan) that was done in 1862 while he was visiting the Holy Land as the Prince of Wales.

King George II of Greece (1890–1947) was, in all likelihood, the same Prince George who "had a flying dragon on his chest which took eighty hours to complete," tattooed by Tom Riley.

King George V (1865–1936), son of Edward VII, had a dragon tattooed on his left forearm (by tattooist Hori Chyo) when, as the Duke of York, he served in Japan with the British Admiralty on the HMS *Bacchante*, which visited Yokohama in 1882.

King Harold II of England (ca 1020–1066) was the last Anglo-Saxon king of England but the first known royal to have a tattoo. Killed at the Battle of Hastings, he reportedly had "Edith" tattooed over his heart.

King Oscar II of Sweden (1829–1907), Kaiser Wilhelm II of Germany (1859–1941), Queen Olga of Greece (1851–1926), and

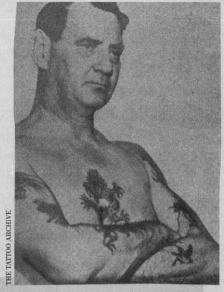

Frederik IX, King of Denmark, was probably first tattooed while in the Royal Navy. He visited George Burchett in London during the 1940s for additional tattoos. The king was very proud of his tattoos and told the Danish press all about them. A Copenhagen newspaper referred to their encounter in London as the "meeting between the two Kings," Frederik, King of Denmark, and Burchett, King of Tattooists.

Lady Randolph Churchill (the American-born mother of Sir Winston Churchill) were all tattooed by Tom Riley.

Prince Christian Victor of England, a grandson of Queen Victoria, was tattooed with his regimental crest (the King's Royal Rifle Corps) and died in the Boer War.

Prince Francis of England (1837–1900), the first Duke of Teck and the father of Queen Mary, had "a frog with one hind leg stretched out and the other bent as if preparing to leap at a fly sitting a few inches above the Prince's elbow" (*Memoirs of a Tattoist*, by Peter Leighton).

skin must be either new or sterilized, including the inks, their containers, tissues, the razor, Vaseline (or lubricants), the gloves, the alcohol, the needles, and the tubes (we'll get to what all this stuff is for in chapter 5). The chairs should be clean, as should all the surfaces where tattooing materials are placed.

We Meet at Last

Eventually, probably at the tattoo shop where he or she works, you will finally have a chance to meet a tattooist, perhaps even a tattooist recommended to you. The following are some questions that you should consider asking. Although these veteran inkslingers may have heard these questions a thousand times that day alone, do not hesitate in the slightest to ask them anyway, whether it's your first tattoo or your fourth. This is your tattoo that we're talking about, and the process of getting one safely and sanely. You need to be comfortable with every bit of it, and satisfied as well.

About the Artists:

Q: May I look at your portfolio?
A: Yes. (Hopefully their portfolio is filled with many great photos of great tattoos, photos that aren't yellowed with age. There might even be photos of trophies or tear sheets of their work in magazines. You're looking for the same great quality of tattoos in photos that you would in tattoos seen in person. If there aren't a lot of photos, then the artist most likely hasn't done a huge number of tattoos. Also, in portfolios, many times the photo is taken right after the tattoo is done, so it's normal to see redness and swelling.)

Tattoo Prices

In an informal poll at the TattooSymbol.com Web site in 2004, the following were the results when people were asked how much they had paid for their most expensive tattoo:

It was free: 0%

$25–$50: 2%

$51–$100: 8%

$101–$250: 19%

$251–$500: 11%

$501–$1000: 5%

Over $1000: 4%

I don't have a tattoo: 48%

In a classic bell curve, skewed slightly to the right, these poll results revealed that most of the responders who were tattooed (39%) paid between $100 and $250 for their tattoo. What is really interesting, though, is that nobody has gotten all, or perhaps even any, of their tattoos for free. Those are good signs, and not simply because of the money that is moving in the tattoo industry. It's a good sign because, as in all things, you get what you pay for. Most people who had a tattoo, amounting to 60%, paid less than $250. However, a significant 40% have paid more than $250 for a single tattoo. Many things influence the cost of a tattoo: whether you've selected flash or want a custom design, the size of the tattoo, the pay rate of the tattooist, the reputation and location of the shop, perhaps even the time of year (with winter being the slowest season). The cheapest tattoos fall into categories such as tiny hearts or lettered names. There's no reason that one of these can't be fantastic; they're just small. On the upper end, those people who spent over $1000 for a single tattoo (8% of the tattooed responders) are people who are craving—and getting—a relatively large custom piece that takes more than an hour or

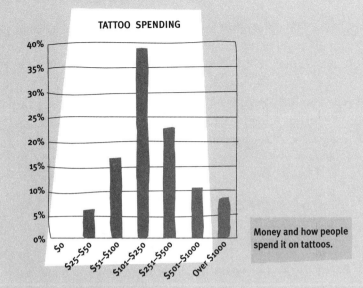

TATTOO SPENDING

TERISA GREEN

Money and how people spend it on tattoos.

two to ink. Hidden in this 8% number are people who have likely spent well over $1000 for their most expensive single tattoo—people who are having world-class tattoo artists create large pieces of work that were conceived as a whole (perhaps a full sleeve or a back piece) over multiple sessions.

Q: Do you do custom designs?
A: Yes. (You're not trying to be a prick, but even if you're not looking for a custom design yourself, it's nice to know that the artist has the artistic chops to get the job done.)

Q: How much would you charge for (fill in the blank)?
A: (If it's a single tattoo and you've got the artwork, or it's in the flash on the wall and it's not particularly large, then expect a lump sum price. If it's custom work or particularly

large or complex, then you might get the hourly rate. Simply take note of the information. There is no point in dickering on the price. It has been said over and over: Rule #1 in the tattoo money game is that great tattoos are not cheap. The corollary to Rule #1 is that cheap tattoos are not great. Part of the price of a tattoo is the overhead for the shop: rent, sterilization equipment and procedures, disposables, and ink.)

If You Know the Biz:

Q: Where did you apprentice? Does the owner of the shop tattoo?
A: (If you don't know the biz, these answers mean nothing to you so there's no point in asking. But tattooing is learned through apprenticeships and by doing. If your tattooist was apprenticed or schooled by top-notch tattoo artists, then that's better than having learned it from a book or a video (because you can't). It's a sort of pedigree, history, and genealogy all in one.)

About Infection:

You haven't seen the chapter on the process of tattooing yet, but rest assured that anytime your skin is opened, even with teeny tiny needle holes filling with ink, you risk infection from viruses and bacteria. Tattoo artists must understand this, but they don't have to be surgeons. They must, however, know the proper procedures for preventing infection when it comes to their own practices.

Q: Do you sterilize your instruments?
A: Yes, with an autoclave. (There is simply no substitute for a medical autoclave to sterilize metal instruments, i.e., the needles and tubes. They should all be individually packaged and opened in front of you when you get your tattoo.)

Q: How do you know the autoclave is working properly?
A: An operator for the machine has to keep a logbook and the machine is spore tested once a month.

Q: (You could ask about whether the artists wash their hands, wear gloves, and wipe down the entire work area with a germicidal solution before and after a tattoo, but you can also probably observe this. If you don't see it happening, then ask.)
A: Yes, I thoroughly wash my hands and use gloves, changing them whenever is needed during the procedure, such as when answering a phone call or fetching something.

Q: Is everything else besides the sterilized equipment new and single use?
A: Yes, the inks are dispensed into new ink caps which are disposed of after use. Tissues are disposed of as well as gloves. Ointments, trays, and razors are also discarded.

Bring Your Wallet

All tattoo artists charge by the piece and by the hour, depending on the type of tattoo being done. Smaller pieces, just lettering, or flash will have a set price. More complicated, larger, or custom work will likely be priced by the

hour. On the low side, a simple small heart or name might be $50. On the high side a large Oriental dragon might be $800. At a minimum, the artist will need to make enough money to pay for the chair (the overhead of the shop, which includes rent, inks, and other supplies). In larger cities, that minimum amount is going to be about $50, while in less densely populated areas where the cost of living is less, it could be as low as $35. An average-size tribal armband of average complexity might be between $125 and $175 and a single solid color kanji (like a name), about an an inch square, could be $35 to $50 (the minimum amount). On the hourly scale, an average tattooer charges an average of $125 per hour while the top in the field, a world-class tattooer, might be $275 per hour with a three- to four-month waiting period for space on their calendar. Even when you're paying a single set fee for a piece, the price will likely work out to about $100 to $175 per hour. Shop around but don't dicker. If you really only have so much money, then say so. See if perhaps the artist is having a slow afternoon, or day (or even season, like in the dead of winter) and if there might be some other time when they'd be willing to work on you for the price that you have in mind. Some clients might get the outline done first, save more money, and then get the shading done later.

Most tattoo artists do a mix of single pieces for a set price as well as custom hourly work. They will take appointments and also do walk-ins (because they're stationed at the door or because their appointment has cancelled). What are you paying for at the high end? Experience and artistic excellence. Having both of these greatly increases the chances that you'll get the perfect tattoo for you. Luck will also yield a great tattoo, but do you really want to rely on luck when it comes to a tattoo? Let finding the world's best burger rely on

Culture Vulture

While international boundaries are more permeable than ever and designs from cultures everywhere are being mixed and matched around the globe, think before you ink, so that you're not caught off guard. Be aware of the design's original meaning and the context in which it was used, if at all possible. Knowing that the Japanese carp or koi is a symbol of masculine achievement in that country doesn't mean that women can't or shouldn't wear one as a tattoo (although it's not likely that women raised with it as a symbol for Boys' Day will acquire one). It is a tattoo of exquisite beauty which lies well on many parts of the body and can be done small on a foot or huge on a back, and is often done on men and women in the West, where the aesthetic value of the design and its allusion to Oriental culture drive its popularity. These people do not feel bound, nor are they, by traditions, especially those in another place. In other cultures, however, tattoo symbols are imbued with specific and special significance. Among the many Polynesian peoples, for example, different styles and placements of tattoos break down along gender, family, class, and status lines and are sometimes intertwined with religious beliefs and social expectations. Quite the opposite, the tribal style of tattooing in the West is generally *inspired* by the designs of Polynesia and is appreciated for its bold and yet delicate beauty, without being an exact

Marquesan whale tattoo design (redrawn by author after Willowdean Handy, *Forever the Land of Men: An Account of a Visit to the Marquesas Island,* 1965).

TERISA GREEN

duplicate of indigenous designs, nor wanting to be. Occasionally, however, tattoo clients will choose a specific design or placement without understanding the ramifications. As only one example, men in the West who believe that they are acquiring a warrior tattoo on their chins may be unpleasantly surprised to find that Maori women wear the chin *moko*. Modern Maoris who ascribe specific and honored meaning to particular patterns may likewise be unpleasantly surprised to see those same exact patterns being used in offhand and casual ways on people not deserving, by lineage or achievement, to wear them. Your tattoo design choice is up to you and nobody can stop you from getting what you want. Just think before you ink.

luck, but not your tattoo. Experience counts not only for the artistry, but can sometimes also lead to novel and compelling artwork, knowledge about which techniques and equipment yield the best results, adjusting on the fly for different skin types, and sometimes even reducing the anxiety of the client.

Freebie

Let's assume that you're only interested in being tattooed in a licensed and reputable tattoo shop. From time to time, if the shop runs an apprenticeship program (not all shops are willing to take the time) and beginning tattoo artists are deemed ready to begin tattooing, you might be able to get a free tattoo from someone who is just starting out. Generally, these won't be custom tattoos—in other words, you select

your design from the flash—and they won't be complicated either. It's a free tattoo performed by a beginner in a professional environment under supervision and it fits your price range. If that's what you can afford, then so be it. Do, however, recall the rule and the corollary given above. Also, ask your list of questions just as you would with any other tattoo artist.

Free tattoos can also be gotten from people working out of their homes, who may not be affiliated with any particular tattoo shop. These tattooists may be just as good, but are their sterilization procedures up to snuff? An autoclave is not a cheap piece of equipment.

Tipping the Scales

Should you tip your tattoo artist? There are no hard and fast rules on tipping. Tattooing is a service industry just like many others. Are you the type of person to tip a hairdresser or waiter? If so, then you'll probably want to tip your tattoo artist if you can afford it. It's understood that sometimes clients will come into the shop with a set amount of money and spend it all on the tattoo, so they can't afford a tip. That's not a big deal. What matters most to most artists, tattoo and otherwise, is that their work is appreciated. If you like your new tattoo, the perfect one that you've been envisioning, then say so. If you're thrilled with your new tattoo, then say so, too. Those expressions become more valuable to tattoo artists over time than any amount of tip and often become one of the main bonuses of their jobs, a high point in the day and something to which they can look forward. If you do decide that you can afford a tip, how much should it be?

Again, there are no rules. Clients who spend hundreds on their tattoo may tip forty dollars while someone who gets a fifty dollar tattoo may tip fifty dollars. General tipping guidelines would make your tip somewhere in the 10 to 20 percent range, depending on how pleased you are with the tattoo and the service.

Courtesy Is a Two-Way Street

At all times in your tattooing process, you should be met with courtesy and respect. It may be a business—in fact it is a business—but tattoo artists should not be trying to talk you into something simply because they want to tattoo it. Also, in the way of the world and in any given group of people, there will be some rotten ones. No matter how much you want a tat-

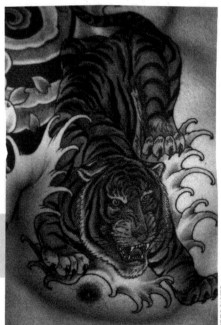

Tiger tattoo in the Japanese style, by Greg James, Sunset Strip Tattoo, Hollywood, CA.

GREG JAMES

too, never allow anyone in the process to take advantage of you, exploit you, or make you feel uncomfortable in the slightest. There's always some amount of chitchat and casual conversation, but tattooists should also keep the appointment professional and stick to business. For example, was the tattoo artist courteous in answering your many questions? That's a good sign. Did he or she give you a chance to think about the answers? Give you time to look at flash or a portfolio? Throw out some options for you to consider? Listen to what you had to say? Your tattoo artist needs to be working with you to help you find your best tattoo design and placement choice. How you feel about your tattooist and whether the two of you can communicate and get along are oftentimes deciding factors, especially when choosing among good tattooists, any one of whom could probably easily complete your tattoo design. In the end, you have to be comfortable with your tattooist because ultimately you are placing trust in him or her.

4 | You, a Needle, and Your Skin

NOT ONE GREAT COUNTRY CAN BE NAMED,
FROM THE POLAR REGIONS IN THE NORTH TO
NEW ZEALAND IN THE SOUTH, IN WHICH THE
ABORIGINES DO NOT TATTOO THEMSELVES.

CHARLES DARWIN, THE DESCENT OF MAN, 1871

Although this chapter includes probably the most important information that anyone who is considering a tattoo could receive, if you're reading it you've already made the commitment to get inked and there's no need for medical jargon or scare tactics. Sterile techniques and equipment are now the standard throughout the industry, rather than the exception. In fact, it remains true that there has never been a case of HIV transmission documented as the result of a tattoo. Confusion and misinformation about the actual physical process of tattooing abounds, however, and this chapter gives you information that is fundamental to understanding many other facets of the process. In the most basic of definitions, tattoos are pigments that are inserted into a certain layer of the skin and remain there, for all intents and purposes forever. But understanding the

details of that basic definition, and how a tattoo is applied, will help you to understand, for example, why certain colors change faster than others, or how the skin can renew itself constantly and yet the tattoo remains.

Tattoo Taboo: The word "needle" is virtually never used in tattoo studios because . . . well, it upsets people. Instead, needle configurations are often substituted: a five round or seven flat, for example.

Your Biggest Organ, If Not Your Favorite

Measuring in at an average six pounds and about twenty square feet is the largest organ of the human body—our skin. And what a fantastic organ it is! With a remarkable ability to repair itself, it is the first and best defense that we have against all manner of microorganisms, chemicals, and even ultraviolet radiation. It helps to regulate body temperature, it is an important sensory organ, and it keeps those precious bodily you-know-whats pretty much inside where they belong. You really just could not get along without it. Add to all of that the fact that it is constantly rejuvenating itself. Every three to four weeks, you completely slough off the dead outer skin cells (the epidermis) and have a completely new covering. In fact, during an average lifetime you'll lose about forty pounds of dead skin.

Wait a minute, though. If your skin is constantly renewing itself, how can a tattoo be permanent? Cuts, scrapes, and slight burns all come and go, although they sometimes leave a scar. We've all had that experience. Is a tattoo a

scar then? Nope. The key to this little conundrum is understanding the difference between the epidermis (the outermost layer of skin) and the layer right under it, the dermis. The total thickness of human skin averages somewhere between one and two millimeters but the epidermis is only a small fraction of that, only a tenth of a millimeter thick. In the epidermis are the pigment cells that allow tanning and give skin their natural color, but not much else—other than skin cells. The dermis underneath, however, is a pretty complicated place. Heat, cold, pressure, and pain are felt through tiny bulges of the dermis as it intrudes a bit into the epidermis. Also, the dermis has collagen fibers, sweat glands, hair roots, nerve cells, lymph vessels, and blood vessels. You can think of it as the skeleton of the skin, giving it elasticity and body because of the collagen and elastic fibers. Wow, all that in such a shallow space!

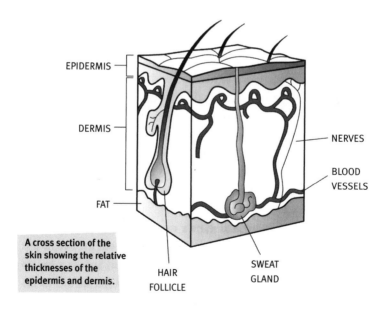

A cross section of the skin showing the relative thicknesses of the epidermis and dermis.

Getting under Your Skin

Here is the answer to that burning conundrum above, which should be obvious by now. A tattoo is a collection of pigment that resides in the dermis and below the epidermis. In other words, when you're looking at a tattoo, you are looking right through the epidermis. That's a pretty revealing statement. Your immediate conclusion is that, holy cow, Batman, the epidermis must be penetrated for pigment to reach the dermis and that ink (pigment particles mixed in a fluid) is only just passing through. Right you are. In a professional tattoo, the pigment is delivered with astonishing accuracy and speed into the target zone of the dermis. Of course, there are many ways to accomplish this delivery. You could bet good money that they've all been used, one way or another, over the last several millennia. In all of these methods, though, the end result must simply be that the epidermis is penetrated and that ink is inserted into the dermis. Can you tattoo too deeply? Oh, you bet. Pigment that is deposited too deeply may be more difficult to see clearly, might be accompanied by scarring, or could be more readily carried away. Pigment that only reaches the epidermis gets sloughed off over time. So, like Goldilocks, you don't want it too shallow and you don't want it too deep. You want it just right.

All right then, assuming that you're going to be tattooed in a professional studio with a modern tattoo machine, just how does this optimum delivery happen? The needles on the business end of the machine are rapidly moving up and down a very minute distance. Of course, now you know why that distance is so small. It's a distance designed to deliver pigment into the dermis. The needles ride in a hollow tube which the artist grips like a pencil. By dipping the needles and the end

Centers for Disease Control and Prevention

"A risk of HIV transmission does exist if instruments contaminated with blood are either not sterilized or disinfected or are used inappropriately between clients. CDC recommends that instruments that are intended to penetrate the skin be used once, then disposed of or thoroughly cleaned and sterilized between clients. Personal service workers who do tattooing or body piercing should be educated about how HIV is transmitted and take precautions to prevent transmission of HIV and other blood-borne infections in their settings. If you are considering getting a tattoo or having your body pierced, ask staff at the establishment what procedures they use to prevent the spread of HIV and other blood-borne infections, such as the hepatitis B virus. You also may call the local health department to find out what sterilization procedures are in place in the local area for these types of establishments."

Sterile procedures in tattooing are the rule today, not the exception.

of the tube in the ink container, the ink coats the needles and the tube acts as a small reservoir. As the needles reciprocate up and down that tiny distance, they are introduced to the surface of the skin, where they travel through the epidermis and into the dermis, carrying your ink with them.

Does all of the ink stay? No—and for many reasons. That's why tattoo pigment in the skin is just a potential tattoo until healing is completed. The epidermis will receive some ink just from being in the way. As new cells push up from the bottom of the epidermis layer, the old skin cells at the surface slough off. Whatever pigment was deposited in the epidermis will also make this little journey and eventually disappear. The dermis, however, will receive ink and it will attempt to carry the little pigment foreign bodies away using the cells of your immune system, to capture them, and/or do nothing. You're hoping that much more of the latter two take place than the former, which generally happens. In fact, the process of capturing the ink begins taking place almost immediately.

Unfortunately, the molecular healing process of tattoos, with all of its teeny tiny details, has not been studied and isn't that well understood. You can understand how that would be. Few of us would subject our brand-new tattoos to repeated medical sampling. But there are some observances from which we can piece together a general story. The injury to the skin which has taken place causes all sorts of white blood cells to march in, clean up, and begin healing. The immune system sends out the call for macrophages (also known as scavenger cells) which come along and try to gobble up any stray pigment particles and haul them off to the garbage dump (the local lymph node). In the area of a tattoo, right after the tattooing has taken place, the epidermis, the dermis, and the base membrane (in between the dermis and epidermis) can become mixed up—move into

each other's territory. If the tattoo has been done well, and the area hasn't been overly tattooed, then the epidermis and base membrane are pretty well intact, with some holes that need to be sealed. In that case, the tattoo heals in almost the same way as a sunburn: The epidermis reacts by overproducing cells that result in the tattoo peeling a few days later. In the other case, the tattoo may scab and peel over a longer period of time.

After about a month, the ink-containing cells concentrate near the base membrane, between the two layers of skin. When the base membrane has fully recovered and is intact, further loss of pigment through the epidermis is prevented. As we already know, the epidermis will have rejuvenated itself every three to four weeks anyway. After two to three months, ink particles will only be found in the dermis: captured in fibroblasts (a special skin cell especially good for making connective tissue) or simply lying inert in the dermis, not in any particular cell, having never been successfully captured or carried away. The fibroblasts are in turn enmeshed in a network of connective tissue, effectively trapping and immobilizing them. And there they stay for the life of the tattooee . . . and beyond.

Superficially Speaking

Of course, you can't see any of that epidermis, dermis, ink particle stuff happening unless you have Dick Tracy glasses or electron microscope vision. Instead, what you see on the surface of the skin as a tattoo is being applied is ink, Vaseline, a clear fluid called lymph fluid, and just a little bit of blood, all mixed together. Because they're in the dermis, lymph and blood vessels are punctured in the process of the tattooing and

Biker Pavement Tattoo

You know that if kids can do it, it can't be too hard to get a tattoo. This class of tattoos, as real and permanent as any, is sometimes referred to as a traumatic tattoo, and we've probably all seen one. Don't you remember those dopey kids in school who poked themselves with a lead pencil and it left a small dot? That's a traumatic tattoo. More problematic and way more traumatic is the classic biker pavement tattoo, obtained in the excruciating circumstance of people sliding across surfaces paved with black asphalt. Lead shot and bullets can also leave a permanent pigmentation, but consider this your very last resort in getting a tattoo!

release a small amount of their fluid. The area of the tattoo will get red and perhaps also a bit puffy. Your tattoo artist will tattoo and then wipe away excess ink and body fluids, dipping the tattoo machine needles and tubes into the ink container to pick up more ink, repeating this process until the tattoo is complete. Since tattoo artists don't have spy glasses either, how do they know that the ink is penetrating to the dermis and will remain in enough quantity to create a tattoo? To a large degree, the depth of the needle penetration is set by tattoo artists when they set up their tattoo machines. The needles, when extending all the way, only come out so far; in fact, they're a bit hard to see even when you look at a tattoo machine up close. But in addition to the mechanics of the tattoo machine, the artists' experience counts. They simply have to have seen enough finished

tattoos that are completely healed and remember what they looked like while they were being created, thus linking good results with good technique that can be repeated. They also need to know when to stop, i.e., when enough ink has been placed in the dermis. Although you want clean solid lines and good solid color, you don't want to be overly tattooed (as in too many little holes per square inch—it's perfectly fine to have lots of tats). If the artist is heavy-handed or goes over the same area too many times, you can end up with scarring (where the tattoo seems raised, even after it is healed). Also, some people just scab heavily, scar easily, and even tend to get keloids (raised scar tissue). Like a commercial airplane pilot, your tattoo artist should be the most experienced that you can find, for this and many other reasons.

Death to Germs, Life to Human Beings

Armed now with the mighty knowledge of how a tattoo actually works, you can see immediately that infection might be an issue. Anytime the skin is penetrated, you are at risk for infection, since one of its primary missions is to keep your body sealed. But infection as a result of tattooing is much more the exception in the modern and sterilized tattoo parlors of today than in bygone eras. Nor does it take extraordinary precautions or hospital environments to prevent infection. It requires some training and the practice of sterile techniques, and then there should be nothing to worry about—while you're being tattooed, of course. Later, when you've left the shop, the burden of infection prevention falls on you and, again, you just need to observe some simple rules that we'll cover in aftercare.

There are two kinds of infection that rule the germ world, bacterial and viral (and the ones that cause disease are called pathogens). Viruses are like teeny tiny little robot rockets. They even make little sounds just like the old Space Invaders arcade game—OK, well, not really. Even if they did, viruses are so small you'd never hear them anyway. In fact, they don't survive very well outside of a real living cell, incomplete and robotlike as they are. Human immunodeficiency virus (HIV), hepatitis, measles, chicken pox, and the common cold are examples of viruses. They launch themselves into real cells, invading and replicating until the cell explodes, at which point they are released and launch for other cells. Pretty insidious. Antibiotics don't work against them. Antibiotics are for bacteria. Bacteria, unlike robot rocket viruses, are real animals, living organisms, and about five hundred times the size of a virus. Bacteria are absolutely everywhere: in the air, the water, the dirt, and inside people too. Some bacteria are good, others not so good. Bacteria cause things like the flu, tetanus, diphtheria, and pneumonia. The good news though—transmission of diseases, especially blood-borne pathogens, is easy to prevent.

Tattoo Trivia: *Among the indigenous Yurok of Northern California there was a saying that an untattooed woman looked like a man when she grew old.*

AIDS, the Bugaboo

HIV causes AIDS (acquired immune deficiency syndrome) by attacking the immune system until it's no longer effectively defending the body. Getting an HIV infection is not the same thing as having AIDS, since it usually takes years for the virus to wear down the immune system. There is still no cure for the HIV infection and people who are infected with it will carry it the rest of their lives. It is not, however, the death sentence that it used to be, even for people who do eventually exhibit AIDS. HIV is spread by sexual contact, blood transfusions, breast feeding, and sharing intravenous needles. It's not transmitted through the air or on surfaces, like colds and flus. That's because HIV is a fragile virus and it doesn't survive well outside the body. If it gets dry, for example, it dies immediately. So while many people who are considering getting a tattoo are worried about contracting HIV, there is to date not a single instance of HIV transmission that is associated with tattooing. Hepatitis is a different story.

The Thirty-six Year Ban

In 1961 the New York City Health Department reported that blood-borne hepatitis cases were coming from tattoo parlors. Fearing a hepatitis B outbreak, the city council outlawed tattooing. Of course tattooing never really stopped but it was definitely driven underground. However, with the interest in tattoos continuing to rise and entering the mainstream, tattooists becoming recognized for their artistry, and the growing realization that licensing tattooists was a good way to ensure public safety—since we're hell-bent on getting tattoos

anyway—the city council worked with both the health department and tattooists to challenge the 1961 ban and create useful legislation. In February of 1997, the New York City ban on tattooing was lifted.

Unlike HIV, the hepatitis B virus (HBV) can be spread through all manner of bodily fluids (including tears and saliva). People can have it and not ever know, and some may even recover from it in as little as six months. Other people, unfortunately, will develop chronic hepatitis where even the use of antiviral drugs (remember, it's a virus and not a bacteria, so antibiotics do no good) doesn't stop the progress of the disease and the associated destruction of the liver. While it's the most contagious of the hepatitis viruses, you can actually be vaccinated against it.

HBV is a bad form of hepatitis, but there are at least six types of hepatitis all told: A, B, C, D, E, and G. Hepatitis A is spread from person to person by putting in the mouth something that has been contaminated with the stool of a person who has hepatitis A. This type of transmission is known as "fecal-oral." Poor sanitary conditions and poor personal hygiene contribute to its spread. You are very unlikely to get this virus at a tattoo shop. You are much more likely to get it at a restaurant where the employees don't wash their hands after using the bathroom. Like HBV, there is a vaccine against it. Also like HBV, HAV—and all forms of hepatitis—attacks the liver. Hepatitis C is transmitted through blood only, but the consequences are just as dire as those for B and there is no vaccine against it. D, E, and G are pretty rare, so we'll skip those.

Is there cause for concern? Although more studies are under way, the Centers for Disease Control (CDC) has not demonstrated a relationship between tattooing and an increased risk of contracting hepatitis. Instead, the people who

Twelve-Month Waiting Period

According to the American Red Cross, you must wait twelve months after a tattoo before you are allowed to donate blood. The requirement is a result of concerns about hepatitis (a word which means "inflammation of the liver"). If the one-year wait seems extreme to you, it's all relative. There are some cases in Red Cross policy where the likelihood of acquiring hepatitis is so high that a person would never be able to donate blood again, no matter how much time has gone by (like the intravenous use of drugs not prescribed by a doctor). Of course, you might wonder why they'd prohibit anyone, since they presumably test all of the blood anyway. And that's true; all blood donations are tested for blood-borne pathogens. Unfortunately, though, all the tests in the world don't necessarily catch everything. It's even possible for a person to carry hepatitis and not know it, never showing any symptoms. The incubation period can be relatively long as well, up to six months for hepatitis C. So it's better to be safe than sorry for the American Red Cross. But if your twelve months are up, get out there and donate!

TATTOO ENCYCLOPEDIA, TERISA GREEN AND GREG JAMES

The Rose (or Angel) of No Man's Land is a classic old-school tattoo design. The Red Cross nurses of World Wars I and II were memorialized in tattoos by the grateful soldiers they tended. (Illustrated by Greg James.)

are most likely to contract it are people who share a syringe—an intravenous injection, a fix—even once. In the tattoo industry, HIV is not the disease that people are most concerned with, given its fragility. Instead, it is hepatitis. But the same knowledge and practice of sterile techniques that keep HIV from spreading via a tattoo also prevent the spread of hepatitis. The risk of infection is never zero—not in a hospital, dentist's office, or tattoo shop. But the proper practice of sterile techniques greatly reduces that risk.

Day of the Dead accordion player, by Patrick Sans, Burly Fish Tattoo, Flagstaff, AZ.

PATRICK SANS

Special Considerations

Nobody knows your skin better than you . . . and your boyfriend. Are there things you might not have considered about your skin that might make you not such a great candidate for the perfect tattoo? Do you (obvious enough, but you'd be surprised how many people are surprised by this) have a skin condition? Especially a skin condition where the ability of the skin to heal has been compromised? This might include but is not limited to conditions like psoriasis, eczema, or dermatitis, for example. Lupus and diabetes are not diseases of the skin per se but skin problems are more common in persons afflicted with these conditions (diabetes—dry skin to the point of cracking, peeling, and compromised healing; lupus—skin rashes and sores). Even temporary skin problems like sunburn, poison ivy, or allergic reactions can possibly have a deleterious effect on the outcome of your tattoo.

Health conditions that are not even related to the skin ought to be considered as well. A remote possibility but an example of health issues to consider is mitral valve prolapse, one of the most common heart valve abnormalities, though only 2 to 6 percent of adults have it. People who do have it are prone to acquiring endocarditis (an infection of the lining of the mitral valve of the heart) and have to take antibiotics every time they see the dentist because one of the most direct routes to the heart for bacteria is through the bloodstream from the mouth. If you had a piercing in or near the mouth and bacteria were carried away in your bloodstream, it'd be a similar situation—and likewise for a tattoo.

On a more benign but much more common note, do you have a cold or the flu? Although millions of people have

likely gotten tattoos when they were feeling under the weather, it's not the optimum setup. You are responsible for knowing your own state of health before you go get a tattoo. In the end, your tattooist is not your doctor. If you have any questions or doubts about the health implications for your new tattoo, do the commonsense thing and ask your doctor.

All Roads Lead to Ink

After reading about how complicated the skin is and knowing that the skill and knowledge of the tattoo artist are critical in getting your perfect tattoo, it seems like a complicated affair. In reality, though, tattoos have been going on for millennia and there are probably hundreds of ways to actually accomplish a tattoo. Today in Western culture an electric tattoo machine punctures the skin with metal needles, pushing ink through the epidermis into the dermis. In Japan *tebori*, or hand tattooing, is still regularly practiced. Instead of the electric machine, the needles are attached to the end of a long, thin handle, dipped into ink, and pushed into the skin by the tattooist, almost as though with a small pool cue. Traditionally in Polynesia the tattoo tool, which looks like a very small wooden rake, was dipped in ink, held in place on the skin, and then tapped from above with a small wooden stick, essentially hammering ink into the skin. Historically among the Maori of Aotearoa (New Zealand), thin shallow grooves in the face were created with similar small rake chisels and then ink was subsequently rubbed into the open wound. Among the Maidu of Northern California a sharp piece of obsidian (volcanic black glass) was used to score the skin and a charcoal made from burned wild nutmeg was rubbed in. Among the Chumash in Southern California

Tattoo Trivia: Among the indigenous
Mohave of the California desert, where
both men and women were tattooed, the saying was
that an untattooed person went into a rat's hole at
death instead of the proper place for spirits.

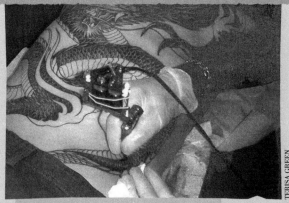

The vibration of the tattoo machine gives it a motion blur as
the tattooist works on shading the scales of a large gray
Japanese dragon back piece.

one technique amounted to painting the skin first, pricking it
with something sharp, and then wrapping it in a pigment-soaked
leaf. There are perhaps countless variations of the very simple
technology of putting ink in the skin but they all accomplish es-
sentially the same thing. In another day and age, in the smaller
and more insular cultures that existed around the world, it's con-
ceivable that the risk of infection may have been less. But it has
never been zero. Organic materials (like wood, bone, or any type
of plant used for twine or coverings) are nonsterilizable (unlike
steel) and are always capable of carrying infection.

Pigments and Reactions

What's in your tattoo ink? It turns out that it's very hard to know. Tattooing is not a regulated industry, although local licensing of tattoo studios and artists is common, and local laws and ordinances govern some health and safety aspects, to varying degrees. However, manufacturers of pigments are not required to reveal the composition, nor are the tattooists who use them. Tattooists can obtain their ink in two ways: They either mix their own or they buy it mixed. Professionals who mix their own tattoo ink are the people who can mostly likely tell you what's actually in it, although they may not. Much of that type of information, along with tattoo machine building and tattooing technique, is trade secret stuff. For you as a consumer to really understand tattoo pigment and the carrier with which it is combined in order to make it liquid, you would pretty much need to be a chemist. As a consumer interested in the safety of your tattoo experience, however, you need not know how to make tattoo pigment or understand the chemistry answers that might be revealed by tattoo artists, assuming they mix their own. The best question that you can ask has to do with history, not chemistry. Ask how long the studio or artist has been tattooing with the same kind of ink that you'll be getting and if there have ever been any safety issues with it, whether they mix it or buy it. You want to hear that the ink has a nice long history of safety. Good quality in the finished product would be good too.

Even when a tattoo pigment has a wonderfully long and perfect history, though, each body reacts differently to the introduction of a foreign particle. In particular, with tattoo ink you may risk an allergic reaction to a product with

which other people are fine. Even people who have had their tattoos for some time could discover, years down the road, that they have suddenly become allergic to something in their tattoo ink. That sort of delayed reaction generally only happens when there is another exposure to the foreign particle, i.e., another later tattoo with the same pigment that makes the body's immune system want to get rid of the particles. The two most common ink colors that might set off an allergic reaction are red and yellow. And that's a shame, since red is also the most popular color used in tattooing (after black, of course). Allergic reactions can vary from some occasional irritation to a constant itching, and cures range from a topical ointment to a prescription drug—even to tattoo removal in extreme cases. If you think that you're experiencing an allergic reaction associated with your tattoo, seek the advice of a doctor.

Magneto

There is also evidence that an MRI (magnetic resonance imaging) can cause a reaction in tattoo ink that contains iron oxide. Iron oxide can be found most commonly in the colors black, brown, red, yellow, and orange, although that's not to say that these colors necessarily have any iron oxide at all. Because iron is a metal that is magnetic (ferromagnetic), passing through the MRI, which is essentially a giant magnet ring, causes a magnetic field to be induced in the iron, which in turn can attract the iron to the MRI magnet and can also cause electricity to run through the iron. Tattoo artists are not required to have you fill out a complete health questionnaire before they tattoo you, and MRI technicians are

What Exactly Is an Autoclave and How Does It Work?

You hear this word everywhere; it's mentioned in laws that govern tattooing, and in advice about tattooing sterilization. What exactly is it? Think of an autoclave as a pressure cooker, literally. In 1679, Denis Papin invented a "steam digester" (the autoclave prototype) and today it is still used in cooking. The autoclave of today is essentially a box that is sealed, and which can reach high temperatures and pressures and sterilize all kinds of things using superheated steam. The pressurized steam destroys microorganisms, killing all sorts of nasty and infectious bugs. It is the quickest, most effective, reliable, and efficient means of sterilization and is a standard piece of equipment in medical facilities, as well as tattoo and piercing studios. When all of the guidelines for the autoclave are properly followed, no living organism can survive one.

The autoclave is essentially a high–pressure cooker that sterilizes metal instruments. It is the gold standard in sterilization equipment, in tattoo shops as well as hospitals.

TERISA GREEN

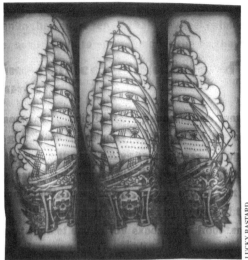

Old-school pirate ship, by Lucky Bastard, Fine Tattoo Work, Orange, CA.

not required to ask you if you have a tattoo. If you think you might have a tattoo that contains iron oxide—and you probably don't know one way or the other—then bring it up with the technician and seek the advice of a doctor before the MRI. The number of cases of tattoo-MRI interaction (ranging from itching and tingling to actual burns) has been very small, though, and the vast majority provide no problem whatsoever.

Healthy and Happy Tattoo

If prospective parents were told of all the possible things that could go wrong with a child's birth, the human race might have faded away long ago. With possibly more than you ever wanted to know and definitely more than you

needed to know, you now have the information that is part of getting the perfect tattoo for you. It also forms the foundation for understanding what happens in the tattoo studio and why you need to follow your aftercare instructions closely. Be encouraged by the simple fact that literally hundreds of millions of people before you have safely and sanely gotten tattoos, many of them multiple times. Be assured by today's commonplace and easily accomplished practice of sterile techniques. But most of all realize that the process of getting happily and safely tattooed is not a big deal, if you know the right questions to ask. If you've read even the subtitles of the paragraphs in this chapter, you're well on your way.

5 | The Typical Tattoo Process

O LE TATAU, THE ART OF TATTOOING, IS STILL HIGHLY RESPECTED
IN SAMOA. ALL MEN, ALMOST WITHOUT EXCEPTION, SUBJECT
THEMSELVES TO THIS PAINFUL OPERATION AS SOON AS THEY
REACH THE AGE OF MANHOOD. HOWEVER, THERE HAVE ALWAYS
BEEN INDIVIDUAL WEAKLINGS WHO AVOIDED THE PAIN, BUT SUCH
PALA'AI (COWARDS) HAVE NEVER ENJOYED THE LEAST RESPECT.

CARL MARQUARDT,
THE TATTOOING OF BOTH SEXES IN SAMOA, 1899

When the big day arrives, surprises are not welcome. From
the moment a customer enters the tattoo shop to the moment
he or she leaves, there is a typical process that is virtually
scripted in the minds of many tattoo artists, and it helps a
prospective tattooee to know in advance what that script in-
volves. Several steps of preparation involving the worksta-
tion, equipment, and pigments take place and may mean
some waiting time spent idly gazing at flash or watching
somebody else get tattooed. The design is prepared with ei-
ther a transfer or a stencil.

Tattoo Tip: Take a picture ID with you.
Most tattoo shops will refuse a tattoo to
anyone who does not have ID.

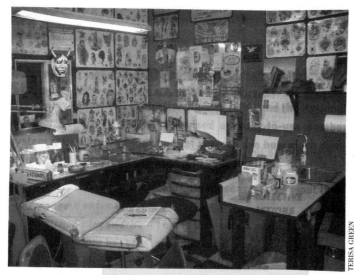

The interior of West Coast Tattoo, located in downtown Los Angeles since 1949.

The skin, no matter the part of the body involved, is shaved and given an alcohol wipe. A temporary ink outline of the design is placed on the surface of the skin and checked in a mirror. And all of these steps take place before a single part of actual tattooing begins. This chapter is designed to relieve the natural anxiety that any new experience brings, by demystifying it and laying it bare. Knowing exactly what to expect, in the order it will likely happen, and the amount of time it will likely last, can mean the difference between a nerve-racking experience and an enriching one. This chapter advises tattooees of some of the potential regulations involved, their responsibilities, the responsibilities of the tattoo shop or artist, and the requirements of payment up front and signing contracts. In addition, the prospective tattooee will learn that tattoo artists also have their own expectations, and that fulfilling these can make for an even better experience and better tattoo.

How to Irritate Your Tattooist in Three Easy Steps:

Step 1. Arrive late to your appointment, then hurry your tattooist.

Step 2. Arrive drunk, then maintain your courage under the needle with frequent sips from the "orange juice" that you've brought in that stylish Styrofoam cup.

Step 3. Tell him you found the same tattoo design across town at another shop for half the price, and then dicker for at least ten minutes.

(I have personally witnessed all of these scenarios. As a bonus, these same steps can help ensure that you get a less than perfect tattoo.)

Before You Get There

You've done all your research, made all your decisions, and have your appointment . . . what, no appointment? Part of the decision-making process was picking your tattooist—someone in whose technical and artistic skill you have confidence, with whom you have some rapport—someone that you trust. Will he or she be at the shop that day or not? Assuming so, will he or she be busy when you arrive? If that is the case, are you going to wait? How long? But why leave any of this to chance? The first thing, then, that you need to do before you actually arrive for your tattoo is to have made an appointment beforehand. (It's not as spur-of-the-moment as some tattoos, but the perfect tattoo rarely is.) The second

thing to do is to take a bath or shower. Whether you've had your bath for the week already or not, be clean and presentable. Don't come directly from the gym in your workout clothes or after you've been digging trenches in the hot sun. Your tattoo artist is going to sit close to you and work with your skin. Don't give him or her a reason to hurry.

On your checklist of things *not* to do before your tattoo appointment is taking any aspirin or drinking alcohol. In both cases, the blood is thinned, which makes for more bleeding and possibly impaired healing. In the second case, though, it's simply poor form to show up faced. You are entering a tattoo artist's place of work and creativity. Is that how you'd want somebody to come to your place of work? Save the drinking for later, when your friends take you out. Besides, you wouldn't want to miss out on a single part of your tattoo experience. When you look back on it, you'll know that you earned your tattoo the way millions of people have for thousands of years.

Dress appropriately for the placement of your tattoo, which you have already discussed with the tattoo artist. If you know you're getting a tattoo on your upper arm, then wear something sleeveless or with sleeves that can be rolled up high enough. If you're getting something on your lower leg, then wear shorts. If you're getting something on your lower back, then wear a shirt that you can lift and pants that are low enough or which can be lowered enough. If you're getting something on your back, girls, consider wearing a button-up shirt which you can then wear backwards and leave open in the back. All tattoo shops will have at least a bathroom where you can change your clothes. Tattoo shops also have areas with more and less privacy. The front of the shop will almost always have a chair or two but also, usually there will be an area that is screened off from the view of people in the front

and the general public who are looking at flash. If you have questions about what would be good to wear, ask your tattoo artist. You don't want to wear clothing (like briefs or a bra) that will leave an impression in your skin in the exact place where you're planning on having a tattoo.

With all of that in mind, do your best to dress comfortably. There's no point in complicating matters by wearing something in which you can't breathe. Keep in mind the possibility that some stray ink might get on your clothes. It doesn't happen all the time, but it does happen. Some people who are in the process of getting a very large tattoo, over the course of several sessions, may even have a certain set of clothes that they wear for tattooing and may even bring their own towel or pillow for extra comfort. For most people getting their first tattoo, though, this would probably be completely unnecessary. Don't even think about bringing your teddy bear.

A typical workstation setup: Sterilized tubes and needles await insertion into the tattoo machine; the single-use razor, palette, inks, gloves, tissues, and water are ready; the work area has been cleaned and covered; the power supply is covered on the shelf below.

The Cutting Edge

Leave it to California to be on the cutting edge of tattoo culture—now, of course, but also in the past. In fact, over time, Native Californians have been inventive in the many ways that they've found to create indelible images in the skin. The Maidu, a group traditionally located east of present-day Sacramento, used a splinter of obsidian (volcanic rock which looks and acts just like glass, usually black in color) to score the skin first. Then charcoal made from burned wild nutmeg was rubbed into the wound. Among the Juaneño, near modern-day San Diego, girls were tattooed as part of their adolescent training, shortly before puberty. Punctures in the skin were created with a cactus spine and then charcoal made from burning agave was rubbed into the punctures. Among the Chumash, who occupied a coastal area ranging from Malibu in the south to San Luis Obispo in the north, one tattooing procedure involved painting the skin with the pigment first. A prick was made through the pigment into the skin with something sharp, and then the tattoo was wrapped with a pigment-soaked leaf.

TERISA GREEN

Native Californian women's chin tattoo styles: "*a*, Yurok and northwestern tribes; *b*, *c*, San Francisco, probably Costonoan; *d*, Sinkyone; *e*, northwestern valley Maidu" (redrawn by author after Alfred L. Kroeber, *Handbook of the Indians of California*, 1925).

What to Bring

Make sure that you bring some form of identification with you, no matter your age. Depending on local regulations, many tattoo shops will have a contract for you to sign. As with any contract, you should read it. Unlike most, it'll probably be pretty brief. You can expect issues of responsibility to come up (for example, allergic reactions to inks aren't the responsibility of the tattoo artist) or the legal age limit for tattooing (different in different areas). In essence, the tattoo shop and tattoo artist are going to limit the amount of responsibility that they are willing to accept to things that they can control: a sterile environment, satisfaction with the work, and the like. They are not going to take responsibility for things that they can't control: your allergic reactions, the particulars and peculiarities of how your skin heals. In order to sign a contract with you, they have to know who you are. The identification that you bring will be used to that end, and to verify your age if you look close to the legal limit.

Bring your money. You've already discussed your design in detail with the tattoo artist. Once the artist has seen the design, and knows how big it will be and where on your body it will go, he or she can give you a price. Body location will change the price since some parts of the body simply mean more work and time for the artist than others. You know what forms of money they'll take: cash, maybe checks (but you should ask), and credit cards. Make sure to bring enough with you for the tattoo and your tip, if you're thinking of giving one after being pleased with the final product. You may be asked for the fee up front, so that they can be sure you've got the money.

Be on time for your appointment. Not only is it courteous

and good business practice—it also helps to have as much time as possible for your tattoo. There may be more appointments after you. Even if you're on time, though, prepare yourself to wait anyway. Tattooing is a people business and people can be unpredictable. Some tattoo clients may need more breaks during their tattoo process than others or may simply need to take the whole thing a little more slowly. Others simply sit down, sit like a rock, and get up when it's done. Of course, even if everything is on time, waiting during preparations is part of the normal process.

Preparations

The following scenario can only be a general guideline since it will most definitely vary from place to place and artist to artist. But in its broad outlines, this is pretty much what you can expect.

When you arrive and are greeted by your tattoo artist, he or she will confirm the tattoo with you (design, placement, colors), see your ID, have you sign the contract, take your money, and then make the preparations. You can watch, you can look at flash, or you can probably watch somebody else getting tattooed. You might have seen all of this before when you made your grand tour of local tattoo shops or when you looked at your artist's portfolio. Your artist will now create the artwork for the outline of your tattoo design, if it hasn't already been done. A simple, clean, black-and-white version of the outline of your tattoo will be drawn or traced. This paper version might be held up against your body for position and placement, helping with that final visualization process of how your finished tattoo will look. Don't have any ink

or temporary tattoos at all in the area where you'll be getting your tattoo. Once the outline is finalized, the tattoo artist will make a transfer, essentially xeroxing the outline onto special transfer paper.

At this point, tattoo artists prepare the work area by wiping the chair or table down with a disinfectant. They may also use Saran wrap to cover these same areas. Then they'll do the same for the surface on which their equipment rests, again wiping it down with a disinfectant and putting down Saran wrap, especially over anything in the area that might be particularly sensitive (like the power supply for the tattoo machine, for example, if it happens to be located on the worktable—you wouldn't want to get any liquid on that sucker). At some point your artist will don sterile latex gloves. These are worn at all times when touching your skin or anything that will be touching your skin. If your artist has to answer the phone or fetch more ink or whatever, he or she will need to put on new gloves each time before sitting down to tattoo you.

Next, the equipment is brought out to the work area. The tattoo machine itself, unopened packages of sterilized tubes and needles, and a disposable razor are placed on the disinfected worktable. You'll be invited to assume the position—take a seat or lie down, whichever is appropriate for your tattoo placement. Before the transfer can go on, your skin will be cleaned with alcohol, using new tissues or cotton balls, and then it will be shaved. No matter if you're a guy or a girl or what part of the body we're talking about (since there is body hair everywhere, even though it's hard to see), your skin will be prepared by removing as much body hair as possible with a single gentle shave. The artist will wipe down the area with alcohol and place the outline of your tattoo, now on the special transfer paper, into contact with your

wet skin. When the transfer paper is removed, it leaves behind a purple outline on the skin that your artist will use as a guide to create the outline of the tattoo. You should check this in a mirror, using a handheld mirror along with the ones on the wall if it's on your back. What you're seeing is a very close approximation of how your finished tattoo will appear in the context of the rest of your body—although it's a far cry from the black outline and shading that will obliterate the transfer ink. Also, don't worry if the transfer seems messy. It's not permanent ink and it only serves as a guideline. If, at this point, you want something changed about location, size, or design, now is the time to say so.

If the transfer looks good to you both, you'll be asked to resume your position. The artist will then set up a palette of inks. Generally a new paper plate or a sterile tray serves to hold the inks that will be used for your tattoo. Inks are stored in sterile plastic bottles with conical tips. The inks for your tattoo will be dispensed from these bottles into new and disposable plastic caps. A mound of Vaseline can be placed on the plate with a sterile wooden tongue depressor and the caps may be dabbed in it so that they stick to the palette. The cap of an ink bottle is removed and wiped with a tissue, and then ink is squeezed directly into the small cup on the palette. Although this process might be repeated later, generally an artist will put down enough cups to hold enough ink for the entire tattoo if it's a small one. Then the tip is wiped again and the cap and bottle replaced. The palette with Vaseline and inks will be placed close at hand at the worktable.

Once the palette is in place, it's time to load the needles into the tattoo machine. While you may not see the inks dispensed, the most important part of the sterilization procedure should be done in front of you: opening the autoclave bags. The tubes are

Edison: Grandfather of the Modern Tattoo Machine

The modern tattoo machine of today has remained remarkably and fundamentally unchanged since it was patented on December 8, 1891, by Samuel F. O'Reilly of New York (Patent No. 464, 801) over 100 years ago. But if O'Reilly was the father of the modern tattoo machine, then Edison was the grandfather. No, they weren't related. Fifteen years earlier, in 1876 (on August 8 to be precise), Thomas A. Edison of Newark, New Jersey, patented an "Improvement in Autographic Printing" (Patent No. 180, 857). His device was intended to speed up the process of puncturing paper with small holes to create artistic patterns—patterns that were later used for embroidery and for fresco painters. To transfer the designs, the perforated paper was laid down over the targeted article and a fine colored powder was dusted over and rubbed into the holes. When the perforated paper was removed, the article had a transfer of small dots which served as a guideline for creating the embroidery or other artwork. The problem was that puncturing a piece of paper with enough holes to form an image was very laborious and time-consuming, and not much like writing or drawing. So Edison decided to put electricity to work on the problem, plus a bit of machine knowledge. What Edison devised was an instrument whose business end resembled a pen. But instead of an ink nib or pencil lead, there was a needle, to perforate the paper. But rather than move the needle up and down by hand, Edison wanted the needle to quickly go up and down without the operator having to do anything other than simply write or draw, just as though it were a real pen. The needle was attached to a long bar that

The 1876 patent of an "Improvement in Autographic Printing" by Thomas A. Edison.

went up the tube of the pen and connected to a small three-point cam, which looks like a triangle with very rounded corners. As the cam (or rounded triangle) rotated, the bar moved up and down, moving the needle up and down as well. But how did the little cam move around in the first place? This is where electricity comes in and where the current version of the tattoo machine owes so much to Edison.

The small cam was at the center of a larger wheel of metal, known as a flywheel. Sitting just behind but not touching this flywheel were two electromagnets. When electricity is sent through a wire to the electromagnet, the metal core in its center becomes a magnet which attracts metal. So when the electric-

The 1891 patent of a
"Tattooing Machine"
by Samuel F. O'Reilly.

ity is on, the electromagnet pulls the metal wheel toward it,
making it start to rotate. But the effect is only momentary. So
by the time the effect is wearing off in the first electromagnet,
a second one located just opposite the first across the wheel is
set going, pulling the wheel the rest of the way through its cy-
cle. Just as the effect on the second electromagnet is wearing
off, the first one is turned on, starting the cycle over again. How
do the electromagnets get their electricity turned on and off at
just the right time? Well, the switch is actually built right into
the wheel. As the wheel rotates it pushes a thin piece of metal
called a spring (now don't picture the shock absorber in your
car or the spring in a bed; picture a small, thin piece of metal

about the shape of the straight part of a bobby pin). The spring moves back and forth as the wheel pushes it out and then lets it come back. On the spring is a place where it can touch the electricity when it's allowed to spring back, making for a complete and working circuit. When it's pushed out, it loses contact, breaking the flow of electricity. The on and off cycle of the magnets is so quick, though, that the wheel appears to move continually. For each revolution of the wheel, the three-pointed cam at its center moves the needle bar up and down three times. It's so much like a modern tattoo machine that the resemblance is uncanny. But it's not a tattoo machine; it's an "Improvement in Autographic Printing." Samuel O'Reilly's machine, fifteen years later, is so similar to Edison's that his patent is only for a new adjustable tubular handle that incorporated a small fulcrum and lever to increase the stroke (the distance of the needle movement up and down) and also an ink reservoir near the tip of the tube.

first removed from their autoclave bags and fitted into the opening in the tattoo machine. Many artists have particular favorites among tube styles and they likely own their tubes, matched to their machines, and they may purchase and manufacture their own needles as well (soldering needles to the bars). The needles are removed from the autoclave bag and inspected by the artist with a loupe. They are inserted into the tubes and attached to the machine. Finally, the machine is hooked up to the power cord, which generally has a foot switch in it for the artist to turn the tattoo machine on and off, hands free. Once the machine is turned on, the artist may fiddle with it or the power supply, and you'll hear it make a distinct

buzzing sound—not so loud that a normal conversation voice is easily heard above it, though. When the machine is running to the artist's satisfaction, he or she will dip the running machine into the first ink cup (generally black to create the outline) and let you know that things are about to start and that you'll be feeling a brisk sensation.

Tattoo Trivia: Sutherland Macdonald, British tattooist and holder of an early British patent for a tattoo machine, is reported to have coined the word "tattooist," preferring it over "tattooer" since he wanted to sound like an artist and not a plumber.

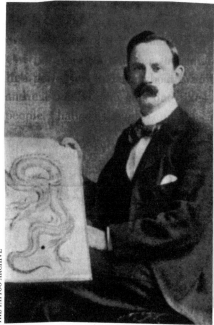

THE TATTOO ARCHIVE

Sutherland Macdonald was first exposed to tattooing in the British Army in the 1880s, first working with hand tools but later receiving a British patent for an electrical tattooing device in 1894. However, in a *Strand* magazine article from 1897 Gambier Bolton stated "that for shading or heavy work Macdonald still used Japanese tools, ivory handles and all." Macdonald started his professional tattoo career in Aldershot, England, but later moved to 76 Jermyn Street, London, and spent the rest of his career in that location. Sutherland Macdonald died in 1937.

The style of different tattoo artists when interacting with customers varies greatly, but this is why you spent some amount of time considering them in the first place. In addition, many tattoo artists will modify their approach or style and tailor it to their clients' needs (a first-time customer may need much more time than a repeat "offender"). They may offer you a moment to reconsider the tattoo before they begin . . . or not. They may ask you if you're ready to begin . . . or not. At this point, or at any time really, if you feel nervous or anxious, that's perfectly natural. Just let your artist know. Artists help hundreds if not thousands of people through the process of getting their first tattoo. Because you're embarking on something that will permanently be displayed on your skin for the rest of your life, it's not uncommon for that realization to come to you in that moment. Rather than worrying about pain, you're worrying about your decision. However, the point of this book is to make sure that you've done everything that you can to be prepared for this moment. Anxiety and nervousness are just a part of the tattoo process, part of the ritual in a sense, and part of every important ritual in the most universal sense. If, however, you're having serious second thoughts, say so. If your gut instinct is that you're making a mistake, then stop. Tattoo artists have seen that happen as well. You need to feel good about what you're doing in the big picture, even if you're nervous at the time. If you need to cancel, then do it, before the outline begins. There's always another day.

Let's assume that all systems are go. Your tattooist may begin with a small line, just a little bit of the outline, and then check on you. Do your best not to move, but don't hold your breath either. At this point, after that first bit of outline, you've felt and now have experience with the pain level.

The Eyes Do Not Have It

You've heard many times that the eyes are windows to the soul. What rot. Sure they're expressive but when was the last time you saw somebody's retina, let alone their soul? If you want to look through a window, though, at least when it comes to the human body, try the skin. A tattoo resides permanently in the dermis layer of the skin, just below the epidermis. As a new tattoo heals, the damaged epidermis is flaked off just like a sunburn. As the epidermis continually replenishes and replaces itself, your new tattoo is eventually covered by a new layer of epidermis. When you look at a tattoo that is forty-five days old or more, you are looking right through the epidermis. The melanin which is responsible for the color of skin is held in the epidermis. Thinking of the skin as a window is helpful when trying to envision how your tattoo will look when the skin has completely healed, especially for people with darker skin tones. Whatever the color of your skin, you will be looking through it in order to see the tattoo. The darker the color of the skin, the darker the healed tattoo will appear.

This is the pain, whether you experience it as a stinging sensation or a rubber band snapping against your skin, that you will likely be experiencing for the rest of the tattoo process depending on the size and complexity of your design. It is a pain that the majority of tattoo clients would describe as manageable or moderate. Many first-time tattoo clients are actually relieved at this point to know that this whole tattoo

thing is definitely doable. A smaller percentage grit their teeth and start a breathing exercise. If, however, you decide that the pain is manageable, then your tattoo artist will proceed, taking the tattoo machine away only briefly for more ink. Longer breaks will come as the needles need to be changed (different needle configurations are used for different parts of the design) and also to change ink colors (generally achieved by rinsing the needles in clean water in a small disposable cup set aside for that purpose).

Your job now is to sit like a rock, without flinching or squirming. Go ahead and talk if you like, but don't whine. Most tattoo artists are quite used to chatting with their clients during the process. If they need you to be quiet, like when they're doing the eyes on your pinup cutie, they'll let you know. Generally your tattoo artist will also let you know when the outline is done. Most people find the outlining more painful than the shading which follows. As the tattoo process proceeds, however, you may find that you need to take a break, maybe because of the discomfort, maybe to switch positions, or just to have a cigarette. Perhaps your tattooist will need a break as well, to take a phone call or see a client who has stopped by the shop. If you want a break, then ask for one. It's part of the routine. Your artist will wipe off the excess ink and body fluids, smooth on some Vaseline, and you can get up and check out the work in progress and have some water or your smoke. The position in which you sit or lie for your tattoo may not be the most comfortable. But your tattooist needs to get the right angle on your skin to do the tattoo well. Be as understanding as possible when it comes to being in an uncomfortable position. Tattooists battle repetitive motion injuries such as carpal tunnel syndrome like everybody else.

Legal Eagles

Laws and regulations on tattooing change all the time. The first bit of business to check for most young people is the age limit.

Alabama—18, allows written consent for minor
Alaska—18, allows written consent for minor
Arizona—18, guardian must be present for minor
Arkansas—18, allows written consent
California—18
Colorado—18, allows for in-person consent if minor is 16 or older
Connecticut—18, allows permission of parent or guardian
Delaware—18, allows written consent
Florida—18, allows for written notarized consent of parent or guardian of a minor
Georgia—18
Hawaii—18, allows for written parental consent
Idaho—18, allows for in-person consent
Illinois—21
Indiana—18, allows for in-person consent
Iowa—18
Kansas—18, written and notarized consent
Kentucky—18, consent of one parent or guardian for minors, written, notarized
Louisiana—18, consent of accompanying parent or guardian
Maine—18
Maryland—18
Massachusetts—18
Michigan—18

Minnesota—18, allows for written parental consent

Mississippi—18

Missouri—18, allows for written consent

Montana—18, allows for in-person consent of parent or
 guardian

Nebraska—18, allows for written notarized consent

Nevada—18

New Hampshire—18

New Jersey—18, allows for written consent

New Mexico—18, allows for in-person consent

New York—18, allows for parental consent

North Carolina—18

North Dakota—18, allows for in-person consent

Ohio—18, allows for in-person consent

Oklahoma—illegal

Oregon—18, allows for written consent

Pennsylvania—18, allows for written consent

Rhode Island—18

South Carolina—21, or consent for 18 and older

South Dakota—18, allows for consent form

Tennessee—18, allows for written consent for 16 and older

Texas—18, allows for a cover-up tattoo for minors with written
 and notarized consent of legal guardian

Utah—18, allows for in-person consent

Vermont—18, allows for written consent

Virginia—18, allows for in-person consent

Washington—18

West Virginia—18, allows for written consent

Wisconsin—18

Wyoming—18, allows for in-person consent

Tattoo Tip: Wiggle Begets Squiggle

Sometimes the muscles of the body seem to have a mind of their own. An involuntary flinch or muscle twitch is not unknown, especially in larger tattoos. It happens and it's nobody's fault. If it happens during shading, it's likely not a problem at all. If it happens during the outline, you'll get a squiggle in the line. How problematic is it? It all depends on where the squiggle is and how big it is. Tattoo artists will pick up the machine as quickly as possible to minimize the squiggle and even prevent it, but sometimes they can't. All is not lost though. It simply gets incorporated into the design. Ever see the scrolls of lettering that say "Mom" where the scroll has an antiqued or a stylized and slightly tattered look to it? The small imperfections or notches designed into the outline of the scroll are the type of break in a continuous line in which a squiggle might find a nice home.

The Party's Over

Well, despite how much you'd like the hot needle massage to continue, eventually your tattooist announces that your tattoo is finished, just when you were getting into the Zen of the whole thing. Finally you get up and look at your finished tattoo in the mirror. Don't be surprised if your skin is red and a little puffy. Lymph fluid and blood may bead up, ever so slightly. The colors often look darker and have more contrast at this early stage than when the tattoo is completely healed. The reddish

swelling of the skin is one contributor to that darker effect. Also, the epidermis is full of ink as well, but we know that eventually the epidermis layer will be replaced with a new clear one, just as before. As you look in the mirror, though, what you see is pretty much your new tattoo and how it will look for many years to come. If you've done your homework and you've picked your design, body location, and artist well, then you're likely not looking at just any tattoo, but the perfect one—for you. No matter the size of your tattoo, you have joined the tribe as fully as it can be joined. Welcome and well done.

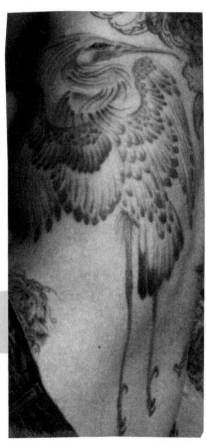

Japanese crane in the *sumi* style, by Robert Benedetti, Sunset Strip Tattoo, Hollywood, CA.

6 | How Your Tattoo Will Change

VIOLET: THAT'S A GREAT TATTOO.
BEAUTIFUL LABRYS. ARE YOU
SURPRISED I KNOW WHAT IT IS?

CORKY: MAYBE.

VIOLET: I HAVE A TATTOO.
WOULD YOU LIKE TO SEE IT?

BOUND, 1996

How well a tattoo ages and how long the colors remain vibrant are most affected by the first three weeks of aftercare given a new tattoo. That statement implies what often goes unstated in the world of tattooing but what is tacitly understood by all— that tattoos do change over time. Because we know from chapter 4 that the skin is constantly changing, we know that the appearance of a tattoo must also change. As skin stretches or shrinks, becomes injured, or simply ages, tattoos also stretch, shrink, and age. In addition, certain colors (red) are more likely to fade than others (blue) and will change more quickly. This chapter describes the changes that the tattooed can expect and how they can help to mitigate unwanted changes with detailed aftercare information and also preventative measures that can be taken during the lifetime of the tattoo.

Transition

It's natural to keep looking at your new tattoo in the mirror at this point, so don't feel too narcissistic. People in the shop will no doubt be looking also. Now that the tattoo is complete, your artist will dispose of all the single-use items and remove the tattoo machine for later disassembly so that the tubes and needles can be cleaned and sterilized. The work area will have the Saran wrap removed, if it was used, and then be wiped down, just as when the whole process started.

The healing process begins almost immediately but your best and first layer of protection, your skin, has been penetrated. Your tattoo artist will take immediate steps to address that situation. Your tattoo will be cleaned with alcohol one last time—the cool feeling is a relief to the hot sensation caused by the swelling. A final coat of Vaseline (or other topical ointment of choice) will be applied, and then a bandage. That's right, your brand-new tattoo is going to be hidden for its first several hours. The bandages vary from shop to shop, even from tattoo to tattoo. Sometimes a sterile pad with medical tape is used. Other tattoos, however, like a very large back piece, are impossible to bandage in that way. Instead, Saran wrap alone, held down by medical tape, might be used. The purpose of the bandage is to prevent infection and promote healing. Any sterile bandage material that accomplishes those goals is good for the task. Other options include a nonstick Telfa pad, and even a diaper for an awkward position on the body.

Your tattooist will tell you what to do to care for your new tattoo. These do's and don'ts are the all-important aftercare instructions. The burden of infection prevention now shifts to you. Despite all efforts made on your behalf by the tattoo

A Moment of Science

It's time to shed some light, as it were, on the alphabet soup that gets tossed around when talking about protection from the sun. Natural light contains a huge range of radiation emitted by the sun, only a small fraction of which the human eye detects (visible light). Beyond visible light, which ranges from colors of red to yellow to green to blue to violet, is the ultraviolet (UV). Below the red is the infrared. We can't see these wavelengths, infrared and ultraviolet, but they're out there and they're dangerous. The sun radiates quite a bit of UV and the whole band has been broken down into smaller segments called UVA (also called black light, used in tanning booths and sunlamps), UVB (not so good for living things), and UVC (which we don't have to worry about because the earth's atmosphere prevents it from getting here). Although the UVA is weaker, you want to be protected from both UVA and UVB in your sunscreen or sunblock.

artist and the shop, you are still at risk for infection once you leave. Listen carefully to what you are told and ask questions regarding anything that you don't understand. When you first visited the shop, you found out whether written aftercare instructions would be provided. These written instructions should now be given to you, because you probably haven't heard a word that's been said since you started staring at your new tattoo. If payment hasn't already been made in full, you'll take care of that now. Now is also the time to tip your artist, assuming that you're happy with your new tattoo

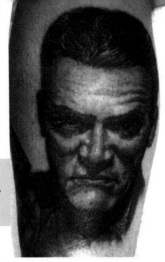

Portrait of James Cagney, by Kari Barba, Outer Limits Tattoo, Anaheim, CA.

KARI BARBA

and you can afford it. Tip or not, though, if you're happy with your tattoo, you might want to say so before you leave.

Also at this point, tattoo artists sometimes like to snap a quick photo of the piece before you leave. Ideally, they'd like to get a nice photograph for their portfolio or Web site when the tattoo is completely healed. But that would mean that clients would have to come back for the express purpose of providing a photo op—which rarely happens. Instead, most tattoo photos are taken right after the tattoo is done. Occasionally, clients return for more tattoos, providing an opportunity to photograph the healed piece.

Five Reasons Not to Get a Tattoo:

Reason 1. Because somebody else wants you to have one

Reason 2. Because it's on sale today

Reason 3. Because it makes you a hipster

Reason 4. Because it makes you an anti-hipster

Reason 5. Because you can't make a free throw without one

Aftercare Calendar

The next couple of weeks are a critical time for you and your new tattoo, which is why tattoo shops will go to the trouble of providing written aftercare instructions for their clients. If you've looked into aftercare at all, though, you quickly realize that these instructions vary from shop to shop, and they have also changed over time. There are a few reasons for that variation. Different products for aftercare are available in different places, even on the same continent. Tattoo artists may be apprenticed using certain products and may keep using them even when they move off and set up their own shop. Experience and a history with these aftercare products is important in the same way that experience is important for the choice of tattoo inks. Confidence in a product or technique builds over years of working with hundreds if not thousands of clients.

But with all the variation of time, place, and tattooist, there still remain some broad and common themes that run through aftercare instructions. The common denominator is twofold: preventing infection and promoting healing. Add to that a third goal of trying to retain as much ink as possible in the tattoo and you begin to understand the reasoning behind all aftercare instructions. The following is a generic aftercare calendar of what you can expect during the first few weeks with your new tattoo and what you need to do to take care of it.

DAY 1: This is the big day—the day you're tattooed. Although most tattoo artists will instruct you to leave your bandage on for a minimum of two hours and hopefully somewhere between two and twelve hours, what they're really shooting for

The Stupidity of Tanning

The tanning booth is no better than sunbathing. If you want to protect your tattoo from the fading and blurring effects of the sun, and your skin from the damaging effects of UV radiation, don't use a tanning booth. The long-term effects of UVA exposure include but aren't limited to premature aging of the skin and skin cancer (which can be fatal). Remember that a tan is your skin trying to protect itself from the damage of radiation. Consider your tattoo a chance to wuss out on suntanning parties and save yourself some melanoma in the future.

See how creepy the tanning booth looks, kind of like a casket.

CLIPART.COM

is that you'll leave it on overnight. You want the tattoo to remain moist and protected for as long as possible. Don't go overboard with this, though. Leaving the bandage on overnight prevents the new tattoo from sticking to your pajamas or sheets on that first night, but the next morning should be considered the upper limit on how long the bandage

should stay in place. Ideally then, on Day 1, you will not see, let alone touch, your new tattoo.

DAY 2: Wash your hands! Always, before touching your tattoo, including removing the bandage, wash your hands with an antibacterial soap. Let this become your new ritual, much like the tattoo artists before they put on their gloves. Remove the bandage, slowly, in case it has stuck to the tattoo. If that's happened, then moisten the bandage with warm water (in the shower might be the easiest way) until it comes free without pulling. Gently, oh so gently, wash your new tattoo with a mild soap and warm water. Your goal is to remove any blood, lymph fluid, ink, or Vaseline that was left on the surface of the skin. You don't want to scrub or even use a washcloth. Instead, use your clean hands and gently work off anything that is on the surface. Don't soak your tattoo for the sake of soaking it, though. Once it's clean, stop washing it. Pat it dry with a clean towel, taking care never to rub it. This is probably your first long look at it, all clean and new in its pristine glory. You will not be applying a new bandage.

Exception #1 in the aftercare game: The vast majority of people will not need a second bandage, but occasionally the double bandage is the best course for some people. Folks who are prone to scabbing or thick scabs or who have an impaired ability for the skin to heal itself or whose ink just doesn't seem to stay (which you would only know from past tattoo experience) might try a second bandage—but probably for not more than another twelve hours. After washing as above, apply another clean coat of Vaseline (or whatever product was used) and rebandage (with the same type of dressing as was used initially, or perhaps just Saran wrap and medical tape).

As the skin of the new tattoo heals, you want to keep it moist

to prevent scabbing, which removes color from the tattoo and which would also create itching and the temptation to touch the tattoo, even scratch it. In order to prevent drying, you'll use a cream to moisturize the tattoo. How often and how much? You want to use enough so that the tattoo doesn't feel tight, dry, or itchy, and you want to achieve a thin coating, since you don't want to clog the pores. What type of cream or lotion should you use? There are many from which to choose, and every tattooee and artist will recommend something different. What it amounts to, though, is label reading. You want to avoid alcohol since it will dry the skin. At this point, you also want to avoid oil, grease, petrolatum (which is in Vaseline), and lanolin (animal oil extracted from wool) since these will clog pores. You want to avoid fragrance since it doesn't do anything for you and could prove to be an irritant to freshly tattooed skin. What are your choices? They fall into two main categories: products made just for tattoo aftercare and products you can buy at any drugstore, grocery store, or pharmacy.

Specialized tattoo products (Tattoo Goo, Black Cat Super Healing Salve, THC Tattoo Aftercare, etc.) may be no better or worse than regular moisturizers at the supermarket. Again, it amounts to label reading. Some of these specialized products, typically sold in tattoo parlors, contain beeswax or dyes and fragrance. Some contain mixtures of homeopathic herbs, vitamins, and oils. Regular moisturizers and lotions (Curel, Lubriderm, A and D Ointment) are much the same, without the cool packaging and the word "tattoo" in the name. Again, these may contain petrolatum or lanolin and dyes and fragrances. You ideally want something as moist and neutral in terms of its chemical composition as possible.

An antibiotic cream perhaps? Well, here's the deal with that. Many, many, many people use antibiotic creams in the

T Minus Fifteen Minutes and Counting

The amount of UV radiation that is pouring down on any given day at any given time varies quite a bit. In the winter, because of the tilt of the earth, the sun's rays have to pass through more atmosphere than in the summer, dissipating some of the harmful UVB radiation. Cloud cover doesn't necessarily protect you, though, since the UV radiation isn't in the visible part of the spectrum. The worst time of day for UV exposure is from ten a.m. to four p.m., so the best time to be out in the sun is before ten a.m. (yikes) or after four p.m. (can anyone say margaritas at sunset?). Also, the higher in altitude you go, the less atmosphere, and the more UV radiation. In general, though, on a day of moderate UV radiation (five or six on a scale of ten as determined by the US Environmental Protection Agency), fair-skinned people can expect to burn in less than fifteen minutes.

Pacific Northwest sun design, illustrated by Greg James.

TATTOO ENCYCLOPEDIA; TERISA GREEN AND GREG JAMES

aftercare of their new tattoo (like Neosporin, Polysporin, Bacitracin, Bepanthen, etc.). An antibiotic, however, is for killing bacteria and these may not, hopefully will not, be present. Antibiotic creams do not necessarily promote healing. In addition, in a very small percentage of people who

are allergic to certain antibiotics, a relatively high dose through all those punctures in the skin can lead to the ultimate in allergic reactions, anaphylactic shock—a full-body allergic reaction that is characterized by breathing difficulty and plummeting blood pressure. So, while an antibiotic isn't really necessary unless an infection develops, it will do no harm unless you just happen to be allergic to it.

Avoid wearing tight, restrictive clothes—including shoes if your new tattoo is on your foot—right over the top of the new tattoo. Wear clothing that breathes, allowing fresh air to reach the tattoo, cotton being ideal. No nylon stockings, for example, or polyester shirts. They don't breathe, and they can also stick to a new tattoo.

You might also want to avoid hard workouts that flex the new tattoo or cause excessive sweating. Remember that your skin is healing, and these first few weeks are critical to the final look and longevity of your tattoo. A small amount of prevention now is worth untold rewards later.

So, on Day 2, remember to wear appropriate clothing and take your moisturizer with you, along with some antibacterial hand wipes or liquid to wash your hands before you moisturize your tattoo.

DAY 3: Take your shower as normal and do your best not to soak your tattoo, although you can gently wash it as on Day 2. Wash your hands and apply your moisturizer as often as necessary to keep the tattoo from getting dry.

DAYS 4 TO 14: Unless you notice signs of an infection or allergic reaction, your tattoo will go through a couple of different phases in this two-week time period. Ideally, your tattoo will not actually scab in the sense that we normally think of it. In-

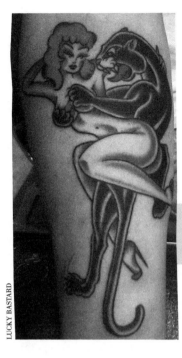

A crawling panther pinup, by Lucky Bastard, Fine Tattoo Work, Orange, CA.

LUCKY BASTARD

stead, the colored and damaged epidermis may simply peel, just like a sunburn, becoming flaky and falling off. Like a sunburn, you don't want to help it. Never scratch or pick at the skin (or scab) of your new tattoo. Never, never, never. The thinner the scab, if there is one, the better, even paper thin. Thick scabs delay healing and can remove color from the new tattoo. Adhere strictly to the "NOs" (see sidebar on page 139) in the first two weeks. If itching is driving you crazy, you might resort to an antihistamine, but check with your doctor first.

DAYS 15 TO 21: In general, tattoos will be completely healed somewhere between two and three weeks, although most will take only two weeks. Until your tattoo has completely peeled or the scab has completely fallen away, your tattoo is not

Worst Time of Day for Sunburn

The US Environmental Protection Agency (EPA) and the National Weather Service (NWS) have devised an easy-to-use number system called the UV index so that you can see how much damaging UV radiation you can expect in your location.

EXPOSURE CATEGORY	UV INDEX	PROTECTIVE ACTIONS
Minimal	0–2	Apply sun protection factor (SPF) 15 sunscreen
Low	3–4	SPF 15 and protective clothing (hat)
Moderate	5–6	SPF 15, protective clothing, and UVA and UVB sunglasses
High	7–9	SPF 15, protective clothing, sunglasses, and make attempts to avoid the sun between 10 AM and 4 PM
Very High	10+	SPF 15, protective clothing, sunglasses, and avoid being in the sun between 10 AM and 4 PM

When the UV index rises above 4 (0–4 is low and 10+ is very high), it can take less than thirty minutes of sun exposure to damage your skin.

complete. Even if the peeling has finished or the scab is gone, the new epidermal layer that forms over your tattoo is going to be quite sensitive. By week three, if your tattoo is completely healed, you should still avoid sun, although you can go back to all your other vices—swimming, sauna, etc.

Just as when you sat down for your tattoo and signed your contract, remember that tattoo artists are not medical doctors. The guidelines that they give you and the guidelines given above are just that: generic guidelines which work for the majority of the populace. Only a medical doctor can give you medical advice and he or she is the only person that you should be consulting for such advice. Don't rely on what your friends say or have done. Don't rely on word of mouth. Your primary sources of information are your tattoo artist, in the form of aftercare instructions and based on experience, and your doctor, based on training.

Pop Quiz: When did tattooing originate?

A. On the island of Samoa in the eighteenth century

B. On the road with Jack Kerouac in 1952

C. In the Stone Age (ouch)

D. In ancient Egyptian ports of call

E. With Celtic warriors, ca 100 BCE

ANSWER: C, probably in the Stone Age, or Upper Paleolithic era, about forty thousand years ago, as evidenced by bone tattoo tools and some pigments excavated from an ancient cave in France. It may well qualify as the world's second oldest profession, if not the first.

Public Enemy Number One

Once your tattoo has completely healed, feel free to frolic in the hot tub and splash in chlorinated beverages all you like. When it comes to the sun, though, from here on out it is your tattoo's number one enemy—Destroyer of Pigment, Vanquisher of Color, Fader of All Things Once Bright. It's ironic, of course. You want nothing more than for your friends to see your new tattoo. Hell, for strangers to see it too. But tattoo viewings are best left to the great indoors, no matter what the beach at spring break looks like.

You're used to the sun having an effect on your skin. In response to the radiation of the sun, it gets darker. You get a tan. That happens to all skin types, from white to black and everything in between. The pigment is called melanin and it's produced by melanocytes in the epidermis. In darker skin, melanin is in a constant state of production. However, melanin is not produced in response to all radiation; it is specifically counteracting ultraviolet (UV) radiation. The skin produces melanin in response to UV light as a protective mechanism so that the melanin can absorb the UV radiation and protect other cells from UV damage. That's all well and good and right. But consider how a darker epidermis affects the look of your tattoo. In order to see your tattoo, remember, you are looking through the epidermis. The darker the window, the darker the tattoo will look.

Tattoo Lingo Lesson: *sleeve—complete tattoo coverage of the arm from the shoulder to the wrist.*

Aftercare NOs

NO Swim

NO Sea

NO Sauna

NO Soak

NO Sun

NO Scratch

NO Sweat

NO Sex (just kidding)

Fade Out

Tattoos fade just like all other color that comes under the rays of the sun. The technical term is photodegradation. Like the snapshot that you left on your dashboard for months or the red heart in bumper stickers that say "I [heart symbol] Pain" or whatever it is you love, all pigments fade when exposed to the sun. Both UV and visible sunlight contribute to the process of fading colors, but it's that nasty old UV that is also the culprit in a lot of skin problems. When it comes to color, radiation from the sun attacks the chemical bonds that absorb light. All pigments absorb light as part of their normal function. When you're looking at a red heart, the reason you see red is because the blue and the yellow are being absorbed and only the red reflected. All pigments work this way, including those used for tattoos. They absorb some

colors while reflecting others. When the chemical bonds are broken down at the molecular level by the nasty UV radiation (which they also absorb, to their detriment), they lose their ability to absorb and reflect different colors. Less red is reflected and possibly also more blue and yellow, which used to be absorbed. What we see in the end product is a less intense red. Since tattoos are generally composed of darker colors (outlines of black as just a start), they are clearly absorbing more light than not (since they are reflecting less—this is why black clothes in the summer sun make you feel much more hot than white). If you want to preserve color, then keep it in the dark, like the wall paintings in the tombs of the pharaohs.

Tattoos battle another fading mechanism as well, since they are impregnated in a living organism, also known as our skin. We already know that if the tattoo pigment has not penetrated to the dermis and has instead ended up primarily in the epidermis, then the tattoo will seem to fade as the epidermis routinely sloughs off and rejuvenates itself. The process of forming new epidermal cells that push their way up from the bottom to the top of the epidermis where they are shed, carrying tattoo pigment right along with them, is some thirty-five to forty-five days. In the truest sense, this is not a faded tattoo per se. It's an inferior one, since it never reached the dermis. Even for pigment that reaches the dermis, however, there are still some obstacles to overcome.

Until your tattoo pigment has taken up permanent residence within the dermis in a fibroblast (a stringy type of cell that makes up connective tissue), your body will treat it like the foreign body that it is, attempting to capture it for escort out. The immune system tries to engulf the pigment molecule with a type of white blood cell, the largest of which is a

A Stretch Mark Is Essentially a Scar

As a body builds up fat rapidly, elastic tissues in the dermis can't stretch far enough and may actually tear, leaving behind a form of scarring when the tears heal. At that point, the dermis can no longer retain or return to its original shape. Stretch marks may appear pink, red, or purple in color, sometimes turning into glossy skin that seems streaked with white. Recall, of course, that the dermis is also where your tattoo resides. Stretch marks can most certainly mar an existing tattoo. Conversely, tattooing over any kind of scar tissue is not easily accomplished and is not always successful.

The skin—and a tattoo—can only stretch so far before being damaged.

TERISA GREEN

macrophage. Sometimes the pigment molecule is just too big, however (size does count), so the immune system may try to break it down into smaller parts by dissolving it. Tattoo pigment doesn't generally just dissolve but nevertheless, over time, your immune system will capture what it can and

then transport it away in the lymph system. If you've been tattooed, the lymph nodes closest to your tattoo likely carry tattoo pigment. After all is said and done, however, the immune system carries away only a small percentage and the remainder is captured in fibroblasts.

Which colors fade the fastest? It depends on the particular molecular composition of the pigment used. Some of the chemical bonds are less stable than others. We've already seen that the ingredients in tattoo pigment are largely unknown and, if known, their composition is sometimes held like a secret. The overwhelming anecdotal evidence for tattoos, however, is that red seems to fade the fastest. In tattoos that are twenty to fifty years old, sometimes the red is completely gone.

Tattoo Trivia: According to the *Guinness Book of World Records*, the longest tattoo session lasted for thirty-three hours and was completed by Chris Goodwill (UK), who tattooed Kevin Budden (UK) at the Electric Pencil Tattoo Studio, Plumstead, Greater London, UK, on April 12–13, 2003. Eight designs were tattooed onto Budden's body during the attempt.

Best Defense

The best defense in the skin game is not necessarily a good offense. The best defense in the battle of fading tattoos is to combat tattoo enemy number one, the sun, by running away. The easiest and the most effective thing to do is cover the tattoo with clothing. A tattoo that is done well in

the first place, healed properly, and protected from light can remain vibrant for many decades. Ironically, of course, this isn't why many people get a tattoo. They get it to show it. So if you gotta show it, then show it indoors. If you gotta show it outdoors, do it in the winter on a cloudy day. If you gotta show it outdoors in the summer, do it in the early morning or late afternoon. And if you show it outdoors at all, use sunblock, always, always, always, even in winter on a cloudy day.

Sunblock and sunscreen are not created equal. A sunscreen chemically absorbs the UV radiation, not unlike the melanin naturally present in your skin, attempting to prevent as many of the rays from reaching your skin as possible. Sunscreens are generally transparent after they've been rubbed in. A sunblock actually physically blocks the sun from hitting your skin. You're probably familiar with the white nose treatment that lifeguards and sailing competitors wear. Those are examples of sunblocks, probably white zinc oxide. However, sunblocks don't necessarily need to look like geisha makeup. Today they are available in a microbead form that is also transparent. The American Cancer Society recommends a sunscreen or sunblock rated at least SPF 15 in order to protect your skin from the damaging rays of the sun. Applying it correctly is also a must as long as you're going to use it: apply twenty minutes before being in the sun, twenty minutes after (think of it as the second coat of paint that gets the thin spots), and every two hours after that. As you may recall, your tattoo resides in your dermis while the cells that create a suntan and natural skin color reside in your epidermis. That means that your tattoo will not protect you from a sunburn in that spot. What's good for your skin is good for your tattoo. Neither is maintenance free when treated right.

Signs of Infection

Infection of a tattoo and allergic reactions to tattoo inks are both rare today. These, however, are some of the signs that would indicate that you need to seek a doctor's care immediately. In the case of infection: increased pain, swelling, redness, heat, or tenderness around the tattoo, red streaks extending away from the tattoo; pus; swollen or tender lymph nodes; a fever of 100 degrees F or higher. In the case of an allergic reaction: a rash in the area, hives, wheezing, difficulty breathing, swelling of the throat.

Stretch and Shrink

Tattoos will stretch and shrink, but only within limits. Moderate and gradual weight gain or loss will have little effect on a tattoo except to stretch and shrink it accordingly. Think of birthday balloons that are slightly overinflated and underinflated. You can still read "Happy Birthday" pretty easily and the letters maintain their relative spacing and composition. However, other types of rapid weight gain or loss could be another matter. For example, women who are considering having children might want to think twice about an abdominal tattoo placement. Similarly, men who are planning on getting seriously into bodybuilding might want to reconsider their upper armband. Stretch marks (often associated with pregnancy but which can also afflict all women as well as men) can also appear on the arms, thighs, and buttocks and even the hips and lower back.

Blur(b)

Tattoos will blur for some of the same reasons that they fade. As the chemical bonds are broken and the molecules begin to break down as a result of exposure to the sun, the body's immune system, always on the prowl, will attempt to take the smaller molecules away. In addition, tattoos on areas of the body that stretch constantly (the elbows, knees, ankles, feet, and even hands) will also blur more easily over time, for all the reasons that we've discussed above. Tattoos done in skin that has already been damaged by overexposure to the sun also seem to be more susceptible to blurring, with the skin less able to hold the ink securely in position.

Ch-Ch-Ch-Changes

Tattoos change over time but there are simple and common-sense steps that can mitigate unwanted changes, perhaps even preventing them completely. Tattoo artists are loath to give a number on how many years a tattoo will last (which is essentially forever) or how long it will look good (which is so variable that there's no good answer). The way a tattoo holds up over time is so dependent on its initial quality, the healing period, its maintenance, and the variations of people's skins that it is impossible to predict. Even a well-executed, simple, lettered word, for example, placed on the knuckles and never covered in the sun, might begin to blur and fade in its first summer, especially given the stretching of the skin over the joints. The same exact lettering, however, on the back of the shoulder, which healed properly, never saw the light of day, and never suffered excessive stretching or

What Is SPF?

SPF stands for sun protection factor. Just like the name implies, you can think of it as a division or multiplying factor. Let's say you're going to be in the sun for ten minutes. If you use a sunblock or sunscreen with an SPF of 15, you'll only get one-fifteenth the amount of UVB radiation that you would have gotten without a sunblock. You can think of it the other way around too. Let's say you can be in the sun for ten minutes, unprotected, and not get any skin damage. If you use a sunblock with an SPF of 15, you could lengthen that period to a hundred and fifty minutes. The SPF rating only applies to UVB radiation, but that's the most damaging sort.

TERISA GREEN

How do you spell SPF?

shrinking, might remain nearly as crisp and legible in its second decade as it did in its second week.

Finally, though, let us acknowledge that as the skin naturally ages, the look of our tattoos changes as well. Age spots and wrinkles take their toll on the clarity and pristine color of our tattoos. Given enough time, even the boldest and

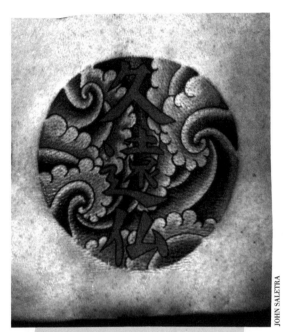

Japanese kanji, by John Saletra, Tabu Tattoo, Venice, CA.

darkest outline softens, inevitably blurring to a minute extent. The lines appear to grow ever so slightly thicker and the gaps between them seem to narrow, sometimes even disappearing. Shading that was once bright and solid becomes a touch less immediate and vibrant. Pigment is moving imperceptibly over time on a cellular level as the elasticity and resilience of our skin naturally declines. For these changes that come simply as a result of time, there is no escape—for our skins, our tattoos, or ourselves. Instead, only our attitudes toward that process count and dictate whether we see an aging tattoo as attractive or not.

7 | How to Change a Tattoo

In a perfect world, everybody who wants a tattoo gets one and everybody who gets one likes it forever. Tattoos and people change, though, and not all tattoos are created equal. In some instances, people, their tattoos, and their tattoo design choices change to the extent that removing the tattoo entirely is the most desirable choice. This chapter acknowledges the obvious fact that some people will want their tattoos touched up, fixed, covered, removed, and even some combination of these. It offers information on all of these different approaches to changing a tattoo, including which approach is best suited to the different types of tattoos and the typical scenarios where tattoo changes are wanted.

Touched

Tattoo touch-up is part of the course of business, and some tattooists are constantly getting their own tattoos touched up in order to keep them looking fresh and great, sort of like hairdressers constantly doing each other's hair. A touch-up can take care of a variety of issues that may arise in a tattoo, although holidays (see chapter 3) spring to mind as the obvious candidate for this type of fix. Because small holidays are generally such a minor touch-up, many tattoo artists won't charge for them. It's always best to go back to the same tattooist who did your tattoo for the touch-up. You'll be assured of the same inks (composition and color) and workmanship. If you chose your tattoo artist wisely, then you have some amount of rapport with him or her as well.

Although tattooees may find it hard to believe, tattooists are aware of the amount of pain that their clients experience. First, of course, most tattoo artists are heavily tattooed themselves. They know firsthand what being tattooed is all about, much more so than the vast majority of their clients. Second, experienced tattooists can gauge the level of the tattooee's anxiety or pain by the way their skin ac-

cepts the ink. Without your knowing it, your body is reacting to your psychological and emotional state and creating real effects such as tightening in your skin. Tattoo artists are also aware of your breathing and, of course, the expression on your face. At some point, for a small percentage of tattoo clients, the better part of valor is to call the tattoo done—for the day. Minor touch-ups that can be done later, perhaps minor gradations in shading, a more solid line in a sensitive area, or maybe just a bit more ink in a spot that had been glossed over, are sometimes best left to a second visit. Then again, if you never came back, these aren't necessarily the kinds of touch-ups that make or break a great tattoo.

A touch-up is something that can sometimes help a faded tattoo. Because different tattoo inks break down at different rates, not all colors fade at the same speed. If the rest of a tattoo is still fairly fresh and only the red needs to be darker in small areas, maybe the red in a snake's eyes, for example, a tattoo artist can put new red over the old, doing his or her best to blend the red colors. The same goes for any color, of course, including the outline. If your entire tattoo has faded, it's not a touch-up; it's a complete redo.

Not all tattoo changes can be fixed with a touch-up, though. Stretch marks are a good example, depending on the color of the stretch marks and the effect that the lack of elasticity in the skin has meant to the overall design of the tattoo. Only a visit to a tattoo artist will let you know. Likewise, a tattoo that has blurred may not be a good candidate for a touch-up. Ironically, though, if the tattoo continues to blur at an accelerated rate (for whatever reason) it may enter into touch-up territory sooner rather than later.

Redo

For people who've exposed their tattoos to the ravages of the sun or who simply have had their tattoos for decades, there comes a time when a redo might be the most attractive alternative. Once skin has been tattooed, however, it is never the same. To tattoo over it again will likely be more difficult, and it is also likely to produce a different result, even if that difference is barely discernible. Even so, one effect of a complete redo for a tattoo is not only that the vibrancy of a new tattoo is achieved, but occasionally the tattoo also takes on a unique sense of depth and shading that only comes from the presence of all those different pigment molecules in close proximity to one another, old and new. They don't mix per se, but the old tattoo still exists in the background.

Mr. Fix-It

Nobody wants to hear that there are some less-than-competent tattooists out there doing tattoos, but there it is. Lines in the outline may cross where they're not supposed to, or may not meet. Uneven color may abound. Straight lines aren't straight and curved lines don't have a perfect curve. Most people on the street couldn't draw a perfect star to save their lives, but that's exactly what we want from a tattoo artist. And although we may not be able to draw one ourselves, we know immediately when one doesn't look right. In the case of tattoo fixes (need I really say this?) you probably shouldn't return to the same tattooist. A competent tattoo artist should be able to tell you exactly what he'd be able to do for you when he sees your tattoo fix

Maori *Moko*

Early ethnographic accounts of tattooing amount to the letters and logs of early explorers, people less interested in anthropology and a systematic recording of observations and more interested in charting unknown waters. Even so, these earliest accounts are sometimes our only glimpses into the whys and wherefores of people and their tattoos before the tide of European civilization swept over them.

One of the most striking forms of the traditional tattooing practices of indigenous peoples comes from the Maori of Aotearoa (better known to us today as the country of New Zealand). Unlike the vast majority of other types of tattooing, the traditional *moko* (tattoo) of the Maori was done by carving the skin with shallow grooves (by tapping a small chisel with a mallet), creating channels in the skin, into which pigment was subsequently rubbed. Given the greater number of blood vessels and nerve endings in the face, the process must have been harrowing, to say the least.

Although *moko* likely encoded information regarding a person's achievements in life, their status in the community, and their lines of descent, one man in particular gives us a personal

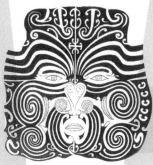

THE TATTOO ARCHIVE

Te Pehi Kupe, Maori chief, 1826, drew his *moko* in amazing detail for his new English friends, without the aid of a mirror. Since the Maori had no written language the drawing of a *moko* was often used instead of a signature.

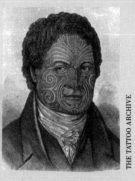

Te Pehi Kupe was a Maori chief who went to England in 1826 on board the *Urania* with Captain Richard Reynolds. While in England, the chief had his portrait painted by John Sylvester.

glimpse into its meaning. Te Pehi Kupe was the "paramount chief of the Ngati Toa at Porirua North Island," a very powerful man during the Musket Wars. In 1826 he was in England to procure weapons and, while there, sat for numerous portraits and also drew many himself. Without the aid of a mirror, he was able to draw his own very complex facial *moko* and once remarked that "Europe man write with pen his name—Te Pehi's is here," pointing at his forehead. He drew the *mokos* of his brother and his son from memory and when he finished that of his son he "gazed on it with a murmur of affectionate delight, kissing it many times and, as he presented it, burst into tears."

candidate. Experienced tattooists can do a lot with shading and solid lines to improve a bad tattoo.

Let's go briefly back to the blurries. A blurred tattoo can happen for different reasons (see the last chapter). Can it be fixed? In most cases, not until the tattoo has blurred so much that a new color on top will stand out as separate from the old (and generally we're talking about the black outline). Tattooing white ink over the old tattoo doesn't work for several reasons. The old pigment doesn't go away, for the most

part. It's already captured in fibroblasts in the dermis. Some of the pigment may become dislodged and be taken away by the immune system, but very little. It's not like painting over an old layer. Instead, the white pigment will enter the dermis right alongside the black and the end effect will be a mingling of the two. Secondly, in the case of white, it never comes out white—and you know why by now. White pigment will end up in the dermis in order to be a tattoo. The epidermis will slough off and eventually replace itself entirely, creating a window of skin that you look through in order to see the tattoo. No skin is clear, not even close. Remember the old "flesh-colored" crayon in the box that never got used? It's not a fabulous color. Whatever the color of your skin, that's the color that you'd see in white tattoo pigment. So don't consider white an option for correcting a blurry outline. Your best bet there is time, a cover-up, removal, or a combination of these.

Crayola Trivia: The crayon color "flesh" that first became available in 1949 was changed to "peach" in 1962, partially as a result of the US Civil Rights Movement.

Cover-up

Ah, the cover-up, where the ingenuity and artistry of the tattoo artist is probably most harshly challenged and where the results can sometimes be nothing less than phenomenal. Cover-ups range from the small and simple to the large and ornate. According to a Harris poll conducted in 2002, the number one reason that people regretted their tattoo was the

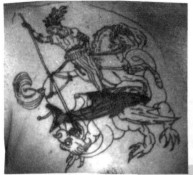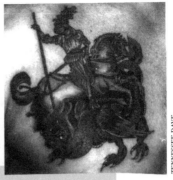

A typical tattoo cover-up by Tennessee Dave of West Coast Tattoo in Los Angeles, CA. A plain blue shark is covered by an intricate St. George slaying the dragon, done in multiple shades of blue.

name in it. I've come down from my chapter 2 soapbox of preaching to the masses (or dozens anyway) that you should never get your significant other's name tattooed on your body. There was probably no point to such preaching anyway judging from the number of couples who flood tattoo shops on Valentine's Day. While Jude Law and Angelina Jolie took the removal route with their name tattoos, others took the cover-up route—Billy Bob Thornton ("Angelina" covered by an angel) and Johnny Depp ("Winona Forever" became "Wino Forever"). The name cover-up is probably the most common and simple one done.

Larger and more complex tattoos are another story. Reasons for covering a larger tattoo are as complicated as the reasons for getting one in the first place, plus the added issues of tattoo quality and changes in the circumstances of people's lives. However, as time goes by, dissatisfaction becomes action and although the tattooee still wants a tattoo, they don't want the one that they have. Perhaps their artistic

taste changed and when the tribal rage of the nineties subsided they decided they wanted to have a portrait of Jesus done in a more conventional fashion. Perhaps the symbol that was chosen is simply no longer relevant: it's a prison tattoo, a gang tattoo, or they simply got tired of it. Any of these reasons, or a combination of them, can result in having one tattoo covered with another. In general, tattoos are covered with larger tattoos that have dark areas in the design that correspond to the dark areas of the old design. That doesn't mean they have to be giant black squares, though. Far from it. Successful tattoo cover-ups give few clues that there was ever another design below them, instead drawing your attention to some eye-catching part of the new tattoo. On the best cover-ups, you'd really have to know what was there previously in order to be able to pick it out.

We'll leave cosmetic tattooing out of this since this type of tattooing is increasingly being performed by people licensed

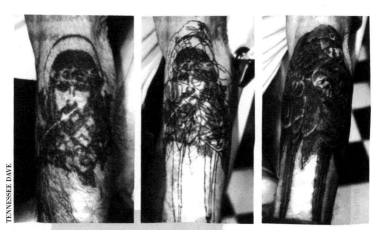

TENNESSEE DAVE

An example of a cover-up tattoo for a parrot fan, by Tennessee Dave, West Coast Tattoo, Los Angeles, CA.

specifically for this type of work and is generally not done in tattoo studios. But aside from the cosmetic tattooing of vertiglio, eyebrows, eyeliner, and lip liner that make up the bulk of cosmetic tattooing, there is also the tattooing of scars. Undoubtedly people with tattoos may eventually suffer some sort of trauma to their tattoo from an accident or surgery that creates a scar. That totally bites, especially

The Mighty Koi

Probably surprising to many Westerners is the large of amount of ancient myth that surrounds these beautiful fish in the Orient and their elevated status there. Generally known here as the brightly colored fish that are common in public ponds and fountains, carp (koi is Japanese for carp) can be found in colors that include white, yellow, gold, a deep orange, and even calico-colored. Particularly beautiful specimens have been known to fetch prices in excess of half a million dollars from private collectors who specialize in their breeding and showing. However, the koi is more than just a colorful and collectible fish. It is also one of the most popular and beautiful of Japanese tattoo symbols—a beauty which belies its symbolic meaning. Although Chinese in origin, the carp is now widely celebrated in Japan, particularly for its manly qualities. It is said to climb waterfalls bravely, and, if caught, it lies upon the cutting board awaiting the knife without a quiver, not unlike a samurai (warrior) facing a sword. This theme dates back to ancient China, where a legend tells of how any koi that succeeded in climbing the falls at a point called Dragon Gate (on the Yellow River) would be transformed into a dragon. Based on that legend, the koi became a symbol of worldly aspiration and

when it ruins a great tattoo. But a scar can sometimes be covered and integrated back into the overall tattoo design. Other times, people who have never been tattooed choose to have a scar tattooed. A bit screwball and grim at the same time is the familiar "cut along the dotted line" instruction with an arrow pointing to a dashed line on the surgery scar. Women who have had a mastectomy have been known to

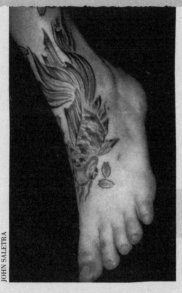

JOHN SALETRA

The versatile koi finds its home in many countries and on many spots of the body. Tattoo by John Saletra, Tabu Tattoo, Venice, CA.

advancement. Eventually, the stoic fish came to be associated with so many masculine and positive qualities that it was appropriated for the annual Boys' Day Festival in Japan, where even today colorful, streaming koi flags are traditionally displayed for each son in the family. In tattoo imagery, especially in combination with flowing water, it symbolizes much the same: courage, the ability to attain high goals, and overcoming life's difficulties.

have their scar covered with flowing vines and flowers to add something positive to a reminder of something negative in the past. Scar tissue, however, is different from undamaged skin and may or may not tattoo well. Consult with both an experienced tattooist and your doctor if you're considering having a scar tattooed. By the way, aftercare procedures for any type of touch-up, redo, fix, or cover-up are exactly like those for a virgin tattoo.

Removal

Ultimately, though, the complete removal of a tattoo is sometimes the only desirable option for some of the inked. Face or hand placement is a good reason to have tattoos removed since they limit the number of employers who would find you an appealing employee (right or wrong as that might be). Having gang tattoos removed as a step in leading a gang-free life is a great reason to have a tattoo removed. Tattoos that result in allergic reactions to the ink, either at the time of tattooing or possibly years down the road, are also candidates for removal if the allergic reaction can't be brought under control. And of course, a simple change of mind, as in the case of the name game, is a perfectly good reason to have a tattoo removed. Some people would never part with a tattoo, wrong name or fashion statement notwithstanding. They view their tattoos as part of themselves, places and times from the past that will never really go away anyway. If, however, you're in the raft of people for whom there is no other desirable alternative, you might consider tattoo removal. Let's talk about the old ways of removal first, mostly so you can be glad for the new.

Old-Style Removal

Lucky for you you didn't want your tattoo removed twenty years ago. Well, hopefully you didn't anyway. A lot of things have changed since then. Back in the day, there were three alternatives. Dermabrasion was the first choice and it's just like it sounds. Imagine taking sandpaper to your skin and rubbing it until there's no tattoo left. All of a sudden pain is spelled "100 grit." Your second option, cryosurgery, would at least freeze the area prior to removing the tattoo, although this procedure was also painful and imprecise. Third was excision, which amounted to a surgeon using a scalpel to remove the tattoo, stitching you up afterward and even taking a skin graft from another part of the body to repair the excision if the tattoo was big enough. Some of these procedures are still used, depending on the tattoo and its specific circumstances. By far and away, though, and to the relief of everyone poised with a sheet of sandpaper over their skin, laser removal is the standard today.

Laser Blazer

The obligatory cautionary statement is that complete removal of a tattoo may not always be possible, even using lasers. Let's go over how it works first, though, and then you'll see why that statement is so common. A laser is light—very concentrated light, but light. Short pulses of this very concentrated light are positioned on a certain color in the tattoo, passing through the outer epidermis layer of the skin to be absorbed directly by the molecules of tattoo

pigment in the dermis. If you've read the section in the last chapter on the damage that the sun can do, this should sound familiar. Just as with sunlight (in particular UV radiation), the molecules of pigment absorb energy which they simply can't handle, breaking their bonds, nearly vaporizing them, and reducing them to smaller-sized molecules. And, as you recall in your newly grown knowledge base, when the particles become smaller, the body's immune system can remove them (white blood cells called macrophages go on the march, scoop them up, and whisk them away). The wavelength of the laser is finely tuned to target a specific color molecule; other pigments in the tattoo or the melanin in your skin are not affected.

How much of the tattoo gets removed depends on so many different factors: size, location, ability to heal, how the tattoo was applied (amateur or professional) and how long ago it was done. Because there are potentially hundreds of different types of tattoo inks out there, and because we never seem to know which ink was being used, it's hard to know if it can be removed. Laser removal success is color dependent, to a somewhat exact degree when it comes to some colors. For example, red tattoo pigment absorbs green laser light. Black and blue tattoos are the easiest to remove while green and yellow are the hardest. In general you could probably say that an amateur tattoo which uses only black or blue ink is easier to remove. Unfortunately, amateurs also sometimes tattoo too deeply, making the pigment harder to reach. A professional tattooist will often mix colors in the tattoo process for a gradation effect, which is also more difficult to remove, but will tattoo no deeper than the dermis and at a consistent depth throughout the tattoo.

Wat Bang Phra

At the Theravada temple of Wat Bang Phra, about thirty miles west of Bangkok, saffron robes, glittering statues, embroidered umbrellas, and paper lanterns are expected sights on the day of a festival. On this day, however, the throng in the square is not composed solely of the devout. Although most of the participants are Thai monks and laymen, mixed in with the crowd is an ever-increasing number of foreign roughnecks: laborers, drivers, gang members, even mobsters. All have come to seek the blessings of the monks, but it is for one particularly symbolic and permanent form of blessing that they have made their journeys: tattoos.

Rooted in Thailand's tradition of Buddhist spiritual service and the country's history of animistic belief, the annual tattoo festival at Wat Bang Phra attracts thousands of visitors. For Western tattoo artists, it has become renowned as one of the last living examples of authentic tattooing. For tourists, it has been sensationalized as an example of an exotic Thai custom. And for the people of the Nakhon Pathom province, it is but one of the myriad temple festivals that take place throughout the year. No matter their background, however, all have come to experience the tangible ways that beliefs are made manifest, both beneath the skin and embedded in it.

From time immemorial, the Khmer and Mon peoples of this rice-growing area actively participated in animistic beliefs. In their everyday experience, they contended with the individual spirits that inhabited the natural objects around them. Shamans, witch doctors, folk remedies, and magical rites are fundamental to animism, and its adherents directly interact with

and influence the spirits. Despite Thailand's current conservatism in the many monasteries and temples across the country, Buddhist practice is often infused with this animistic legacy.

Part of the legacy of animism is the custom of wearing protective amulets, which are thought to deter harmful forces. Before entering the temple's enclosure, many of the men stop to purchase a string necklace bearing two small pendants: a plastic tiger's head, representing power, and a metal medallion of the abbot and head tattooist of the monastery, Luang Phor Pern. But the most potent amulet, the one for which these seekers have come today, is not worn outside the skin but rather on it.

As the men queue up at the various small buildings surrounding the enclosure, the tattoos are finally applied. The tattooists are monks, some former students of Luang Phor Pern. Because of the prohibition against touching women, the great majority of the monks will only tattoo men, although occasionally a monk may specialize in women's tattoos if an assistant can be found. Many specialize in the tiger tattoo, for which the temple is famous, while others are known for their application of protective ancient Khmer scripts. No matter the design, though, it is the tattoo itself that is imbued with power and the act of tattooing that confers the blessing. Offerings of cigarettes, or perhaps orchids, are made to the monks. Dipping their slender metal double-pronged rods into a dark liquid (an undisclosed combination of coloring agent, snake venom, and potent herbs), they repeatedly, rhythmically, and quickly puncture the skin of the devotees. Small dots of ink and blood begin to appear, and with repeated applications, the small dots eventually form an overall design. After finishing, the monks say a quick prayer, and the next devotee steps up. But this is not the end of the experience. Although the majority of

the men in the square report that they feel calmed by the procedure, some begin to shriek and writhe as they take on the various characteristics of their tattoo designs, which are believed to activate inner demons. Eventually, temple custodians, companions, or family members are able to awaken the men from their trances by rubbing or blowing on their ears, causing the demons to leave. The exhausted devotees then return to their senses and attend to any injuries, carrying away with them the assurance that evil has been cast out and that protection from harm will now prevail.

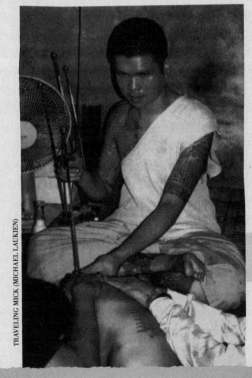

TRAVELING MICK (MICHAEL LAUKIEN)

A Buddhist monk tattoos a supplicant at the temple of Wat Bang Phra in Thailand.

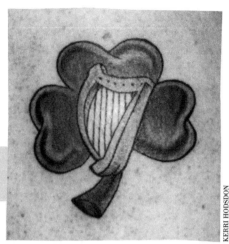

The shamrock and harp of Ireland, by Kerri Hodsdon, Tabu Tattoo, Venice, CA.

KERRI HODSDON

Cruel to Be Kind

Laser removal of a tattoo is reportedly more painful than getting one, and by quite a bit. Each session (and there are usually multiple sessions) may last only minutes in terms of time spent actually under the laser. Dermatologists will tell you not to take aspirin or ibuprofen (or other nonsteroidal anti-inflammatory agents) because they promote bruising. They might, however, be able to offer you an anesthetic, lucky you, like a topical cream or even a local injection. During the healing process, after the laser treatment, the patient is susceptible to infection, just as with getting the tattoo (life is a big circle). Also, as with getting the tattoo, there will be a minimum three-week interval between sessions to allow the area to heal and to give the body's immune system time to carry away the broken pigment molecules.

Side effects of laser removal? I'm so glad you asked. The American Academy of Dermatology says that there is a low

risk of scarring when using lasers to remove a tattoo—a 5 percent chance. Then again, there was a low risk of scarring associated with getting the tattoo in the first place. With any of the old-style techniques, scarring was pretty much expected. Other things that you might look for include hyperpigmentation (an abundance of skin color that may seem darker than normal), hypopigmentation (not enough skin color, which makes the skin seem too light), a remainder of some portion of the tattoo pigment, and as always, the risk of infection. It's not perfect but it sure beats sandpaper or stitches.

Where you'll feel the real bite, though, is in the wallet. Even though it's done in a doctor's office, most insurance plans won't cover something considered cosmetic. Laser tattoo removal ranges from several hundred dollars to several thousand. Be sure that you have, in writing, how much the total cost to you is going to be at the end of the process. On the bright side, at least you don't have to tip.

Choosing a dermatologist for your outpatient procedure is as important as choosing a great tattooist. As with a tattooist, the best referral is a personal one, someone you know who has had a tattoo satisfactorily removed (remember that no one will guarantee they can completely remove your tattoo or prevent scarring). Failing a personal referral, you could ask your personal physician. You can also try the American Society for Laser Medicine and Surgery or the American Society of Dermatologic Surgery for recommendations. Make sure that you're getting a medical doctor who specializes in laser surgery, and it'd also be fabulous if you found somebody who has done thousands of tattoo removals. There's a learning curve just as with tattoo applications, and experience does count.

Laser = Light Amplification by the Stimulated Emission of Radiation

The three lasers most commonly used:

- *Q-switched ruby*—Light from this laser is, not surprisingly, red in color. Because light is absorbed by its opposite color and reflected by its same color, this laser removes most ink colors well, except for red.
- *Q-switched alexandrite*—This laser emits a purple-red light and is therefore best for removing blue-black and green ink.
- *Q-switched Nd:YAG* (pronounced neodinium yag)—This laser can emit a green light and removes red and orange ink the best.

"Q-switched" is just laser talk for high energy that's delivered in short pulses.

The warning symbol for the presence of invisible laser light. During laser removal of tattoos, doctor, patient, and anybody else in the room wears protective goggles.

TERISA GREEN

Gangs and the Military

A couple of special cases when it comes to laser tattoo removal are those of people who were formerly in gangs or on active military duty. Because gang tattoos can be dangerous and prevent former members from getting decent jobs or just getting on with their lives, many large cities

have tattoo removal clinics that will remove gang tattoos for free, as long as some conditions are met. These conditions vary from clinic to clinic. Oftentimes such clinics offer free tattoo removal of offensive or gang-related tattoos to people who are twenty-five years old and younger and who are also doing something constructive with their lives (like school, employment, vocational training, community service). Priority might be given to people who have a job offer that is contingent upon tattoo removal. For men, tattoos are removed from the lower arms and hands as well as the head and neck area. For women, tattoos are removed from places that would be visible in a professional work environment. An average tattoo that is only two-by-two inches takes six to seven months to be removed, with sessions scheduled every six to eight weeks (making that three or four sessions, although ten sessions is not unheard of).

Combo

In the modern-miracle-of-science days when lasers seem like the answer to everything, it might one day be possible to put together some combination of the techniques above to change a tattoo—mixing a small amount of removal with some retattooing touch-up. Most tattoo removal dermatologists, however, are trained in removing tattoos completely. The selective deletion of unwanted parts of a tattoo would require some artistry and precision, neither of which is in the job description. In addition, as has been noted repeatedly, tattooed skin and skin where a tattoo has been removed are never really quite

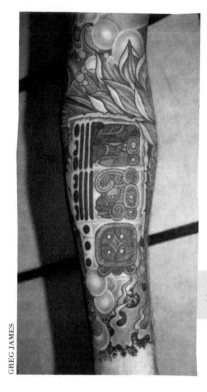

GREG JAMES

the same. Tattooing around the region of a removal may or may not produce acceptable results. Should you come to the eventuality someday that you desire a change in or a removal of your tattoo, consider your options just as carefully as you might consider a tattoo in the first place, if you could start all over again.

8 | You and Your Tattoo

REASON #7 FOR NOT GETTING A
TATTOO: PEOPLE WILL KNOW YOU
ARE RUNNING YOUR OWN LIFE,
INSTEAD OF LISTENING TO THEM!

SAILOR JERRY COLLINS,
TATTOO ARTIST

It's often said in the tattoo community that the only people who care if anybody else is tattooed are the people who are not tattooed. The community of tattooed people is an extremely varied one, far-flung, and sometimes loosely connected, but it is a community nevertheless. It is also still a minority, for all the raging popularity of tattoos in mainstream culture. When people acquire their tattoos, they are transformed, quite literally and potentially, in several different ways. This chapter offers parting words of both caution and encouragement regarding the psychological and social ramifications of having a tattoo. As always, the message is to "think about the ink" in all of its different aspects, from what you choose to symbolize with your design to what you are saying when you do finally show it.

The Tattoo Archive, Berkeley, CA.

Tattoo Talk

The language of tattoos is being spoken everywhere, in dialects new and ancient, and you are part of the dialogue. When we see a tattoo, it creates a response within us. The process may be silent but it's real. Are we curious, repulsed, impressed, or do we just catalog the sight away for future reference? Do we recognize the image; do we know what it means? As surely as if words had passed between us, the tattoo bearer has spoken and we have heard. Sometimes lighthearted and sometimes deadly serious, tattoos are talking and we are about to listen.

The thought that tattoos are a form of self-expression, and therefore a way to communicate, is not new. Many people who talk or write about tattoos mention that aspect. Tattooists have understood the interactive nature of tattoos for a long time—a

very long time. The silent exchange that takes place between bearer and viewer is probably one of the most interesting and important aspects of the tattoo experience and yet it receives curiously little attention. Now more than ever, though, it's time to look seriously at how tattoos are communicating.

While we're used to thinking that photographs and museum pieces can communicate with us, that notion doesn't readily spring to mind when we see a tattoo. There are probably a couple of different reasons why. People often *assume* that they know what tattoos are all about—attempts to get attention or to look intimidating or cool, or simply evidence of poor judgment. Secondly, many times, people don't actually see the tattoo itself. Our parents taught us that it is impolite to stare and so we generally don't. But, in conjunction with presumed knowledge, people see the fact that a tattoo is there and that's really all they need to know—they hardly dare look, let alone take a good look.

It's ink. It's body art. It's just plain art. But it's also advertisement, esprit de corps, fashion, memento, beauty, and boundary. Tattoos are able to fulfill all these roles because they are a kind of language.

Tattoo Trivia: Although the more recently popular "Stewed, Screwed, and Tattooed" is a well-known bit of Sailor Jerry flash (with a bottle, an anchor, and a dame tied together with a banner displaying the slogan), there is also a maritime tradition for "Screwed, Blued, and Tattooed." By the time of World War II, this second phrase had come to mean that a sailor in a foreign port had done everything of importance: got laid, got a new dress uniform, and got ink.

Religious Bans on Tattoos

In an ironic little historical twist, the first known ban regarding tattooing that took place in Christianity came not from a pope but from a Roman emperor—but of course not just any Roman emperor. Flavius Valerius Constantinus was born sometime in the late 280s CE as the son of an army officer. But by CE 324, he had become emperor of all the Roman empire, after the usual bloody run of civil wars, betrayals, and political machinations, eventually adopting Constantine the Great as his byname. On his rise to power he underwent a religious conversion, adopting Christianity and putting a halt to the persecution, which Rome had seemed to enjoy so much. While Constantine didn't put a halt to tattooing (since it had enjoyed a long use among the Romans as a penal tool, used to mark slaves and criminals), he did prohibit tattooing the face. The Theodosian Code preserves his dictum from 316 CE: "If someone has been condemned to a gladiatorial school or to the mines [or quarries] for the crimes he has been caught committing, let him not be marked on his face, since the penalty of his condemnation can be expressed both on his hands and on his calves, and so that his face, which has been fashioned in the likeness of the divine beauty, may not be disgraced." The church proper itself finally took a hand in 787 CE by expanding on that dictum when Pope Adrian I banned all tattooing as pagan and barbaric.

In Judaism, God instructed Moses to let the assembly of Israel know the following (among many other things, of course): "Do not cut your bodies for the dead or put tattoo marks on yourselves" (Leviticus 19:28, New International Version). That seems pretty clear, although it does get much debated.

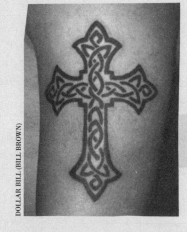

A Celtic knot work cross, in black, by Dollar Bill of Sunset Strip Tattoo, Hollywood, CA.

The Koran is much less straightforward, saying things such as the guilty are "recognized by their marks" (55.41) and the like. However, the Hadith, i.e., the sayings of the Prophet Muhammad, are much more to the point: "Allah's Apostle said, 'The evil eye is a fact,' and he forbade tattooing" (Sahih of al-Bukhari 7.72.827).

The Spice of Life

Tattooed people do not "speak with one voice" even when it comes to the same tattoo symbol. Instead, there is a true celebration of differences—a rich tableau of variety that is nearly infinite. Actresses Drew Barrymore (ornate cross on ankle) and Alyssa Milano (simple cross with chain on the back of the shoulder) tell us something about their religious beliefs. But their tattoos wouldn't have raised an eyebrow on ancient pilgrims to the Holy Land, who showed a bit of variety in their tattoos by using fishes, lambs, sepulchers, Christ's name, and

the date of their pilgrimage in addition to crosses. In fact, the practice may have begun with medieval crusaders. But in the great wide world of tattoos, this is the tip of the iceberg. Religious icons are just one of the many categories that remain ever popular.

Game: Match the Celebrity to the Tattoo

Alyssa Milano	Superman logo
Angelina Jolie	rosary
Christina Ricci	mushroom with face
Fatboy Slim	smiley face with crossbones
Eminem	lion
Mark Wahlberg	dragon
Shaquille O'Neal	snake eating own tail

ANSWERS:

Shaquille O'Neal—Superman logo

Mark Wahlberg—rosary

Eminem—mushroom with face

Fatboy Slim—smiley face with crossbones

Christina Ricci—lion

Angelina Jolie—dragon

Alyssa Milano—snake eating own tail

Eye of the Beholder

Who can say what is beautiful and what is not? We all can. In fact, we all do. Although what makes someone beautiful changes radically from place to place and from time to time, we can almost always agree within our own group about what generally constitutes physical beauty. Remarkably, al-

Tattoo Demographics over Time

Life magazine, 1925: 1 in 10 people is tattooed.

U.S. News & World Report, 1997: Tattooing is the 6th fastest growing retail business in 1996; a new tattoo studio opens every day.

Associated Press, 1997: 35.1% of all NBA players are tattooed.

About Women, 1998: Almost 50% of all tattoos are being done on women.

Harris poll, 2003: 14% of people between the ages of 18 and 24 are tattooed.

DOLLAR BILL (BILL BROWN)

The Superman logo filled with stars and stripes, by Dollar Bill of Sunset Strip Tattoo, Hollywood, CA.

though we may not always share the same ideal of beauty with other peoples and times (for example, the plump Rubenesque portraits of the Renaissance, the purposely elongated foreheads of the Maya, or sixties supermodel Twiggy), we can at least recognize that they were considered beautiful in their own context.

Although Cher, Melanie Griffith, and even Barbie are tattooed, tattooing is not just a simple fad. In fact, it's more than just mainstream fashion or a hint of the exotic. For many, tattoos signal beauty—a conscious desire to be attractive. And not just beauty alone—tattoos have been used to communicate attractiveness, desirability (and also availability) and, quite literally, eligibility for marriage in some cultures. The Yoruba of Nigeria considered some tattoos utterly breathtaking and told the story of a hunter's wife who had an elaborate design put on her abdomen while her husband was away. When he returned and saw it, he was so struck by her beauty that he accidentally dropped his loaded gun, which fired and killed him! Traditionally among the Mer of India, young girls started to be tattooed around the age of seven or eight as part of their preparation for marriage (since a mother-in-law would have ridiculed the girl's parents as being selfish or poor if she had no tattoos). Among the ancient Egyptians, where tattooing seems to have been restricted to women, tattoos had a sexy and sensual nature about them. Our fascination with tattoos as exotic, attractive, or carnal has a long legacy.

Gone but Not Forgotten

If ever there was an always-present and permanent way to memorialize something or someone, it's a tattoo. And if ever there was something significant to say with a tattoo, it would be a memento or memorial. Tattoos and memorials have gone together since the earliest recorded history of tattoos and likely earlier as well. The remembrance of particularly meaningful events in our lives is part of the human experience and it's

been a significant part of the tattoo experience as well. Today tattoo memorials take many forms. Shortly after the September 11 attacks of 2001, "911" memorial tattoos and patriotic tattoos in general surged in popularity in the United States. Other types of memorials are more personal, involving lost loved ones who are commemorated with everything from custom back pieces, to fine line portraiture, to simple dates and a name. Even our pets sometimes find a place in the skin after they've found a place in the heart. The memorial tattoo communicates much. Even so, the bearer of the tattoo might do well to be ready to discuss it since memorial tattoos always evoke at least a question or two. In essence, people who do show their memorial tattoos are making a commitment to have

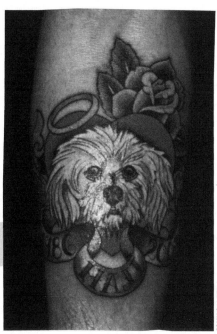

Pet memorial, by John Saletra, Tabu Tattoo, Venice, CA.

JOHN SALETRA

that conversation over and over again.

"As soon as it [the pain] appeared to have subsided a little, I remarked that I was sorry to see her following so useless a custom; and asked if it was not exceedingly painful? She answered, He eha nui no, he nui roa ra kuu aroha! Pain, great indeed; but greater my affection!" Reverend William Ellis, in 1827, relating his observance of a traditional tongue tattoo of mourning in Hawaii.

Civil War Memorials

Some of the earliest written records of American tattooing happen to be of memorial tattoos, specifically those that commemorate the military life, comrades, and patriotism in general. As early as the Civil War, tattooists such as Martin Hildebrandt plied their trade among soldiers near battlefields, shifting from Union to Confederate and back again, as business dictated. Culturally, there seems to have been a commemorative trend in the air, since it was also during the Civil War that the celebration of a holiday known initially as Decoration Day was instituted, when citizens placed flowers on the graves of those killed in battle. Today that holiday is known as Memorial Day and has been broadened to include soldiers from every war. While demand for patriotic tattooing may have first flourished during the Civil War, its popularity has risen and fallen for every conflict since. In the early flash of tattooist C. H. Fellowes, enduring themes which have now become expected in patriotic and memorial tattoos were already in evidence. Fellowes illustrated specific battles such as the sinking of the Confederate cruiser *Alabama*, a blockade runner which had captured, burned or

Us and Them, Them and Us

No type of tattoo is more readily understood than the one that thumbs its nose at society. It is from the subversive tattoo that the "bad boy" (and "bad girl") image is derived and from which tattoos, particularly in Japan and in the West, acquire their less than virtuous and sometimes even dangerous undertones. From rebels without a cause to the clandestine

sunk sixty-eight ships in less than two years, but which was finally sunk by the Union's USS *Kearsarge*. In fact, both crew and officers of the *Kearsarge* had stars tattooed on their foreheads to celebrate the victory. In addition to specifics like these, however, the broader motifs that are with us yet today had also emerged: scrolled lettering that informs us about the memorial, the national flag, patriotic bunting, stars, stripes, and even the bald eagle.

C. H. FELLOWES, *THE TATTOO BOOK*

Civil War–themed flash from the sketchbook of tattooist C. H. Fellowes showing the battle between the Union's *Kearsarge* and the Confederates' *Alabama*.

Japanese criminal underground (the Yakuza), some groups have used tattoos to purposely set themselves at odds with authorities. Tattoos have been used to good effect to create distance from others, signaling individuality and difference. A recent Harris poll showed that 57 percent of the people without tattoos still found tattooed people "more rebellious."

But the view of tattoos and how dangerous they might be has changed radically over time, even in the same location. In the nineteenth century, admirals, earls, lords, kings, princes—and also their ladies—were tattooed. Even Lady Randolph Churchill (Sir Winston's American mother) could display (or conceal with a bracelet) a snake tattoo around her wrist. Does it take blue blood to have a tattoo? No, but being part of an elite group doesn't hurt, and communicating that membership with a tattoo goes on today just as it has in times past. Although the WWE (World Wrestling Entertainment) and the NBA (National Basketball Association) don't require tattoos for membership, many of the most flamboyant and high-ranking athletes sport them.

Employment

Stereotype—something conforming to a fixed or general pattern; especially: a standardized mental picture that is held in common by members of a group and that represents an oversimplified opinion, prejudiced attitude, or uncritical judgment (Merriam-Webster).

Couldn't have put that definition better myself, which is why I didn't. Being tattooed changes you, and not just how you think about yourself. It also, for better or worse, right or wrong, changes the way that other people think about you. Sounding

at this point like the proverbial broken record, having tattoos on the hands, neck, or head puts a person into a very small subset of tattooed people—let's not count tattooists; it's their job to be tattooed. Why is that percentage so small? Why does the military frown upon these locations? Why does a tattoo studio ask you to reconsider your location choice if it's one of these? Because they cannot easily be hidden. Once your head, neck, or hands are tattooed, you no longer have the choice of whether you'd like to show your tattoos or not. Is that a problem? It could well be when it comes to your future job choices. People hold stereotypes near and dear without even knowing it—stereotypes that are slow to fade away.

A study presented in 2003 showed that stereotypes are one thing and that stereotypes mixed with business attire are another. The study involved a man in a shopping mall who asked for help in reading a manual, claiming that he'd forgotten his glasses. Half of the time, his rolled-up shirtsleeve revealed an eight-by-four-inch panther on his left forearm. The other half of the time, his tattoo was covered by the sleeve. The twist in this study comes from the fact that sometimes he wore casual clothing (jeans, sweatshirt, sneakers) and sometimes business dress (shirt, tie, dress slacks, leather shoes). When people stopped to help the man, here's how much time they spent with him:

No tattoo, casual attire—42 seconds of time spent helping
No tattoo, business attire—42 seconds (no difference)

Yes tattoo, casual attire—68 seconds
Yes tattoo, business attire—32 seconds

When people violate our stereotypes or "norms," we become less comfortable and so spend less time with them. In this example, we don't expect to see a businessman with a

large panther tattoo but it's OK for someone who dresses casually. So, when you're flashing your panther tattoo, don't wear a tie or don't flash it on the job.

What about people on the job search? According to salary.com (quoting CareeerBuilder.com and Vault.com), although 44 percent of managers reported that they had tattoos or body piercings (other than the ears), 42 percent said their opinion of someone would be lowered by that person's body art. Seventy-six percent believed that visible tattoos are unprofessional while 81 percent thought piercings (other than the ears) were unprofessional. All types of businesses, right along with military and other government organizations, are revamping their dress codes and body art policies to keep pace with the changing nature of body art. There is no doubt,

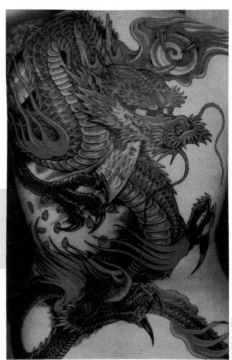

The author's back piece of a Japanese dragon wielding the swirling pearl of wisdom, by Greg James, Sunset Strip Tattoo, Hollywood, CA.

GREG JAMES

Tattoo Song of Samoa

"The tattooing of the chiefs provided the tufunga with the opportunity to sing an ancient song, a free translation of which follows:

Patience. Only a short while, and you will see your tattoo, which will resemble the fresh leaf of the ti-plant.

I feel sorry for you. I wish it was a burden which I could take off your shoulders in love and carry for you.

The blood! It springs out of your body at every stroke. Try to be strong.

Your necklace may break, the fau-tree may burst, but my tattooing is indestructible. It is an everlasting gem that you will take into your grave.

Chorus: O, I am sad, you are weak, O I feel sorry that the pain follows you even in your sleep and you resist it."

Carl Marquardt,
The Tattooing of Both Sexes in Samoa, 1899

This is an example of female hand tattooing. Marquardt notes that the "pattern is now faded with old age." The tattoos along the fingers are called *anufe* which "means worm or caterpillar. In our case the meaning follows the expression of the Samoan natives 'mother of the butterfly,' therefore caterpillar. The tattoos on the back of the hand are called 'fetu' meaning star (the pattern does not require further explanation)" (modified by author from Carl Marquardt, *The Tattooing of Both Sexes in Samoa*, 1899).

TERISA GREEN

however, that at present, visible tattoos change a person's perception of you, sometimes in predictable ways, other times in unpredictable ways. Remember that we talked about the issue of body placement for your tattoo at the outset. It's best considered in that whole decision-making pot of design choice and size. Now that you have your tattoo, assuming that it's not on your head, neck, or hands, it's up to you to decide who sees it and when.

Been There, Done That

Tattoos and the rituals that mark the various stages of life are a natural fit. The primary reasons for that are twofold. One, tattoos involve pain, and pain (as well as fatigue, fear, and hallucinogens) has been used in our rituals for thousands of years. Pain, although considered by the vast majority of people who have a tattoo to be moderate and manageable, nevertheless places people into a different mental state. It creates a threshold which the tattooee crosses voluntarily despite knowing that it will not be pleasant. It demonstrates some amount of courage or at the very least a tolerance for pain. It creates an experience that remains vividly memorable. It is ultimately an expression of the fact that whatever might be desired from having a tattoo, there is a payment for it, and it is something that is fundamentally earned. That notion leads us to the second reason that tattoos and rituals have been closely associated: They are transformative. The traditional rite of passage ceremonies, where people might pass from adolescence to adulthood or perhaps from single to married, help to move us along from one stage of life to another. The ceremonies not only mark the passage; they signal to our community that our

status has changed, that we are transformed. How better to signal that new status than with a visible sign in the skin? How better to experience transformation than in the change from uninked to inked? Many cultures have sensed how the two experiences fit together and have used them accordingly.

The Samoan tattoos that made men more attractive in the eyes of prospective mates were not just intricate designs of great symmetry and pleasing aesthetics. Their appeal was profound because they were not just artwork. Their tattoos symbolized maturity, courage, and stamina—especially since acquiring this particular type of tattoo was grueling and potentially lethal. The total tattoo coverage from waist to knee was performed at the onset of puberty and was a process that might last up to three months. Of course, some men preferred not to endure the ritual. Unfortunately for them, women despised them for their cowardice, fathers rejected them as potential mates for their daughters, and chiefs refused to accept food from their hands, which were called "stinking."

As we pass from one stage in life to another (childhood to adulthood), or transform socially (say from single to married), or are initiated into a group (ranging from sororities to platoons), we often do so with the help of a rite of passage. Sometimes these rites are religious rituals, but certainly not always. In a way that may hearken back to the Paleolithic era and which may have contributed to the persistence of tattooing throughout the world and back through time, the process of committing to the tattoo procedure, experiencing physical pain, taking risk, and eventually overcoming both of these to emerge with the visible sign of one's passage is a ritual, if only in effect and because of the outcome. That said, few modern tattoo artists or clients see themselves as participants in ritual, let alone a rite of passage. For most

Westerners, the process is much more spontaneous, light-hearted, aesthetically driven, and unburdened with deep emotional or psychological content. Even so, tattooing lends itself to a ritual interpretation because of its uncanny resemblance to ritual acts and traditions. There are many specific

Release Your Inner Freak

"But to become a freak one needs a strong character and unusual determination."

George Burchett,
Memoirs of a Tattooist, 1958

Although modern-day performance artists who are fully (or almost fully) tattooed may seem to represent the new and far-out edges to which tattooed people will go in order to be unique or extraordinary, there is truly nothing new under the sun. It is estimated that as early as 1920, over three hundred completely tattooed people had gainfully found employment in the circuses, their fantastic sideshows, carnivals, and fairs—some earning as much as the princely sum of two hundred dollars per week (about two thousand dollars per week in today's buck). One of the most famous of these early entertainers was an Englishman named Horace Ridler. He was born in Surrey, England, around 1892, to a wealthy family, serving twice in the British Army as an officer and leaving service after World War I at the rank of major. In 1922, he embarked on a process of body modification with the goal of becoming a tattooed attraction. It wasn't until 1927, however, when well-known London tattooist George Burchett created his bold zebra stripes (designed in part to cover the older and

types of passage rites into which tattooing could fit, some of which we've already mentioned: life cycles, initiations, social identities. The reason for that easy fit is the fact that at the heart of both rites of passage and tattooing is transformation. Acquiring a tattoo, especially for the first time, is an

coarser tattoos) that his career took off. After 150 hours of tattoo time, with his famous inch-wide zebra stripes (extending over hands, fingers, head, and face), he became known as the Great Omi, one of the most successful freaks in the history of the circus. In addition to his tattoos, he eventually wore lipstick and nail polish, filed his teeth down to sharp points, had his ear piercings stretched to more than an inch in diameter, and had his nose pierced so he could wear an ivory tusk. He retired in 1950 and he and his wife (Gladys, who became known as the Omette and introduced him at performances) relocated to a small village in Sussex where he died in 1969 at the age of seventy-seven.

The Great Omi was the stage name for Horace Ridler. He was one of the greatest tattoo attractions of all time. Tattooed to resemble a zebra by the famed London tattooist George Burchett in the 1930s, the Great Omi worked with some of the biggest shows of the era including Bertram Mills Circus in 1934, Robert Ripley's "Believe It or Not" in 1939, Ringling Bros. Barnum & Bailey Circus in 1940, Wallace Bros. Circus in 1941, Gray Theater in Calgary, Alberta, in 1942, and the Bellevue Circus in 1946.

THE TATTOO ARCHIVE

obvious and visible change. People are undeniably altered by their tattoo, if only in the most superficial and physical of senses. The degree to which people mark their tattoos as symbolic and ritualistic is up to them, as is their participation in the tattoo community.

Community

While some folks reject utterly the notion that they've become part of a community just because they've gotten a tattoo, it's also hard to deny that there is an exclusive and still minority group of people who are tattooed and who form a sort of group based on that fact. Bikers don't necessarily want to be lumped together, well, with anybody probably, but pretty likely not with empowered young career women, punk hipsters, fraternities of law enforcement officers, and the Elks Lodge. However, by virtue of the fact that people everywhere experience the community and do participate in small and large ways, it does exist. Even from the aspect of the rite of passage, people are essentially inducted into membership. Tattoo artists are the core of the tattoo community; again, not all of them include themselves, although the majority do. Were it not for the tattoo artists, their work, their varied styles, their shops, and the conventions which feature them, there would be little community, if any. Tattooed people, a far greater number, make up the rest of the community. It is not a homogeneous group in any sense, being made up of those who feel they are rejecting the norm by being tattooed and others who feel that they have joined a fashion trend. We are bikers, professors, students, machinists, waitresses, soldiers, moms, chiropractors, and writers. We see tattoos as spirituality, art, liberation, beautifi-

cation, esprit de corps, commemoration, life changing, war paint, primitive, a way to make money, and no big deal. For some of us, the golden age of tattooing and the private club have long since passed. For others, new horizons and interesting people who share our same ideas are met at nearly every turn. What you make of it is up to you. Don't be surprised to find that some people will disagree with you. Like any diverse group, there are strata, classes, fringe elements, hangers-on, and every type of person.

The Way of It

Like so much else, what you make of your tattoo experience—before, during, and after—depends almost entirely on you. Without even trying, you will customize your journey to the state of being inked to fit your wants and needs. With the exception of sterile techniques, all of the foregoing words and pictures simply aim to give you some road signs: signs to point the way, signs to use caution, signs that are simply informational. Some signs you will read and heed; others you will totally blow off. That's the way of any journey. But if you didn't know it before you read this book, you better know it by now: being inked isn't a choice, it's many choices. Now go out there and get your ink.

Acknowledgments

It sometimes seems odd to me how often people will assume that I'm a tattooist. Or rather, I should say how often members of the general public assume that I'm a tattooist. It makes sense, I think, given what I write. However, what is much less odd to me but way more interesting is how often tattooists know right away that I am not one of them—like being picked out as a foreigner when visiting another country, despite thinking that you might be blending. It's impossible to say what tips them off since a long-sleeved shirt could hide tattoo sleeves, and sometimes I sit inside the convention booth or chat behind the rail at a tattoo shop. But they know anyway. It could be that I don't know the secret handshake, but it probably has more to do with tattooing being traditionally a closed industry, combined with a history

of exploitation by people outside the industry (particularly photographers and writers) that makes tattooists wary. Even now as tattoos continue to rage in popularity and tattooists are acquiring rock star status, meeting people in the industry is still based on personal introductions.

Thus, my insights into tattooing are just that—a glimpse inside because I am forever outside, by definition. What acquaintance with tattooing that I do have and have tried to pass on here comes not only from research and others close to the industry but, most importantly, from tattoo artists. First and foremost of these generous people is Greg James. Were it not for Greg, the impetus for writing about tattoos in the first place would have been missing. Were it not for the happy hours of research leading up to my own tattoo, the approximately fifty hours of time that he spent creating my back piece, and my perception of my tattoo as being perfect, I would feel that I had nothing to offer potential tattoo clients. Instead, though, I now know that the process of getting a tattoo and having it can be very positive, and there is no reason it can't be that way for everybody. I owe much of that satisfaction to Greg. In addition, not only did he and his clients smile patiently on my efforts to take photographs of tattoo work in progress, Greg went way above and beyond the call, making the ultimate sacrifice for this book: He actually read the thing.

Way before I knew that I would write a book about how to get a tattoo, I knew that I had to know more about tattooing, if only to gain some measure of how much I didn't know. Often enough people asked me questions, in public forums and in private, about the ins and outs of tattooing when I was really only knowledgeable about tattoo symbols. My basic desire was simply to educate myself. When I inquired about sitting in on Robert Benedetti's next apprenticeship, little did I realize

what lay in store. Undiluted and unedited, for several weeks, Robert dipped into his great well of knowledge and experience and poured until we couldn't hold any more: unbroken hours of unscripted lecture and diagrams, days spent at the workbench, demonstrations, handouts, hands-on tutoring, and answers to any and every question, until we ran out. Not one facet of the business, technology, or art of tattooing was left untouched, from mixing pigments to sterile techniques and from ethics to needle soldering. Although my notebook is filled with frantic scribblings and my feeble attempts at flash and using watercolors, these are ancillary to the true value of my time there. Instead, I now know that what sets the elite of tattooing apart from all the rest is twofold: unflinching integrity and dedication to craftsmanship. If I can apply some of Robert's principles to writing and keep from getting my ass kicked should I stray, well, that would be good.

It is said often enough that Tennessee Dave has forgotten more about tattooing than most people ever knew. It's a big claim but even so I'm convinced it's an understatement . . . and not because of his memory. The man is a walking encyclopedia and history book about the industry; there is hardly a person, anecdote, or arcane piece of knowledge that Dave doesn't somehow have tucked away. The fact that he can put up with my pestering speaks volumes about his natural kindness as well as my utter inability to stop picking his voluminous brain. Likewise, in the way of archival sources, Chuck Eldridge and the Tattoo Archive are at the center of the battle against time. A resource for tattooists, collectors, and academics alike, the Tattoo Archive has set for itself the monumental task of chronicling tattoo history, even as it disappears, and is the source of many of the historical images in this book. Although Chuck is a tattoologist, a lofty title that

refers to "one who is well versed in tattoology," I like to think of him as a cross between a tattooist and an archaeologist, in light of our common fascination with the past. In the same way, Traveling Mick has the enviable role of documenting tattooing around the globe, oftentimes with indigenous peoples whose traditions of tattooing seem relentlessly under pressure. A fellow writer, he nevertheless selflessly contributed some of his work regarding tattooing in Thailand. If ever there was a need for the airborne branch of tattoo documentarians, it is now. Rock on.

Part of informing potential tattooees about tattoos is exposing them to a sampling of tattoo designs. There couldn't possibly be enough words to properly acknowledge the debt that I owe to the tattoo artists and photographers who responded to my plaintive plea for great photos of great tattoos. Without reservation, these artists unstintingly opened their portfolios to me and it is an honor to list their names here: Robert Benedetti, Kari Barba, Lucky Bastard, Dollar Bill, Tennessee Dave, Greg James, Kerri Hodsdon, Dianne Mansfield, John Saletra, Patrick Sans, and Leo Zulueta. The privilege was all mine.

In many instances, time and experience end up being the most valuable commodities that people give. I'd like to thank Dr. Kai Kristensen for his thorough and thoughtful review and comments on the health-related material; Dr. Kris Sperry, cofounder of the Alliance of Professional Tattooists, for answers to questions that had puzzled me for some time, and for the interesting chat; Dr. Rosemarie Ashamalla of the QueensCare Family Clinic, East LA, plus the fantastic staff and patrons there, who allowed me to watch their laser removals, chat with them about "getting clean," and feel their sense of empowerment; Dawn Wilson, who shared her laser

removal quest and also allowed me to witness one of those painful procedures; S. S., who was kind enough to relate part of his fascinating journey to being tattooed; Quentin Phillips, who, during one of those marathon tattoo sessions that it takes to get a fabulous back piece, allowed me to photograph him in the midst of it; and tattooist and fellow weasel Angel Cat, who allowed me to photograph his tattoos, with that value-added history of each which only the connoisseur has stored up. Despite the fact that I imposed on all of these people, I was met with graciousness at every turn.

Jessica Papin, of Dystel & Goderich Literary Management, was right on in her assessment that a guide to getting a tattoo was the right next book. Her guidance in developing the tone and outlook of this book was crucial and her critique of the draft marked the first time, ever, that anybody had *offered* to read anything that I'd written. Of course I totally took advantage and the book is the better for it.

Anne Bohner, editor with New American Library, took this project on when it was already under way. Her dedication to making this a cool book and her willingness to include me in the early phases of the book design were way more than I could have expected. It's been a pleasure all the way.

Despite all the guidance and expertise contributed by the people above, I must ultimately, however, reserve responsibility for *all* things unto myself: things like errors, in fact or in judgment. Such errors are mine alone and not to be attributed, not even in the smallest measure, to anyone else.

Once upon a time, two people went shopping after work and bought a sky blue, pencil-thin leather tie. They lived happily ever after, of course, but still it seems like just yesterday.

Tattoos in the Military

Two million veterans currently carry with them one of the most identifiable and permanent symbols of military service ever used: the tattoo. Although they were once solely the realm of barnacled sailors and outlaw bikers, tattoos are now so mainstream that they have almost become a requirement for celebrities. However, the military tattoo is a special case, with a foot in two worlds. In one sense, military tattoos are much like any other type of tattoo, serving many personal purposes ranging from mementos, milestones, and memorials to risk-taking behavior, sheer body adornment, and even curiosity. In the other sense, though, in their long and varied past, these symbols in the skin have also managed to capture not only personal history but military history as well.

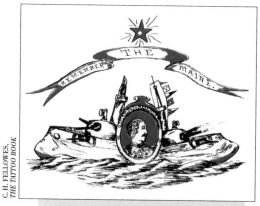

Spanish-American War flash from the sketchbook of tattooist C. H. Fellowes showing the *Maine*, which was sunk in Havana Harbor.

Military themes in tattooing are no recent fad. In fact, the world over, tattooing in general may go back as early as the Paleolithic or Stone Age. Unfortunately we will never know where or when tattooing actually originated since human skin does not preserve well, except in the most extraordinary of circumstances. Perhaps the most famous of all ancient tattooed people is Otzi, the Ice Man of the Alps, who was discovered in 1991. His mummy, created by having been covered with glacial ice shortly after his death, is the oldest known human skin ever discovered—5,300 years old—and it is tattooed. Otzi has fifty-nine separate tattoos, consisting of small dark blue dots, plus signs, and short parallel lines. Speculation about the meaning of his tattoos abounds but two of the most interesting interpretations are that his tattoos are therapeutic (located directly over arthritic areas of his body) or that they signaled membership in a group (perhaps an ethnic or tribal group). In this latter interpretation, we begin to see some of the earliest precursors to military tattoos, specifically the pro-

jection of group identity. One of the most famous of generals in human history was keen to observe much the same in one group of his opponents.

In 50 BCE, Julius Caesar wrote in his *Commentaries on the Gallic Wars* that during his campaigns in Britain in 55 and 54 BCE he observed that "all Britons paint themselves with woad, which turns the skin a bluish-green color; hence their appearance is all the more horrific in battle." While Caesar uses the word "paint," later historians speak specifically of tattoos, and modern historians believe that the warriors who faced Caesar were in fact tattooed. In these earliest of references to tattoos and military action the emphasis is on intimidation. Caesar reinforces that thought by describing them as horrific, not simply blue. The purpose of the tattoos from the viewpoint of the Britons themselves is not recorded. If their intent was to daunt their foe, then they were successful. There are, however, other psychological and emotional by-products of being tattooed. The process of receiving one is painful. It is a pigment, inserted through the epidermis (typically with a puncturing tool such as a needle) into the dermis, where it remains permanently beneath that first layer of skin. Some blood (though not much) will be spilled and infection is risked. People who endure the process, especially if that process is imbued with some ritualistic and symbolic meaning, as was often the case for early peoples, are transformed. They bear the outward sign of having a shared experience and can forever after be identified with a certain group—be it a group of distinct social status, a certain ethnic unit, or a class of warriors. They essentially manufacture esprit de corps, if only as a side effect in the attempt to awe their enemies. As widespread as both tattooing and warfare were around the globe, it should come as no surprise that the Britons were not

the only, nor even the most well-known, group in history to have used tattooing in this way.

In 1778, Captain James Cook, famed British naval explorer, landed at Waimea, on Kauai, in the Hawaiian Islands. The ship's surgeon noted that "The custom of tattooing prevails greatly among these people, but the men have a much larger share of it than the women; many (particularly some of the natives of Mowhee) have half their body, from head to foot, marked in this manner, which gives them a most striking appearance." Or, as later French explorer Jacques Arago described it on the men from Oahu: They were "tattooed only on one side, which produced a very singular effect; they looked just like men half burnt, or daubed with ink, from the top of the head to the sole of the foot." In Hawaii, these early observers noticed that the half-body tattoo seems to have been restricted to warriors. Likewise, in the Marquesas Islands, an identical type of half-body tattoo was used by warriors there. For these warriors, the tattoo was a form of disguise where only the tattooed half of the body was shown to an enemy in combat so that the warrior couldn't be recognized by that same enemy in another encounter.

Military tattooing, in the more Western sense of memorial, however, had a big upsurge in popularity during our own Civil War. Although the 1862 engagement between history's first two ironclad warships, the *Monitor* representing the Union and the *Merrimack* (rechristened the *Virginia* by the Confederacy), was essentially indecisive, with both ships sailing away for repairs, both sides in the conflict claimed victory. False hopes were raised in the South that the Union blockade had been broken, while observers in the North breathed a sigh of relief that it hadn't. Emotions ran high and naval tattoos commemorating the event began to make their

way through the service, along with other more general tattoos. Gunners' mates sometimes wore crossed cannons while boatswains wore anchors. In the case of the Spanish-American War, tattoos actually preceded formal hostilities. Remember the USS *Maine?* Possibly not, since it was sunk in Havana Harbor at the outset of the Spanish-American War in 1898. A suspicious explosion sank the battleship suddenly, taking the lives of 252 sailors aboard her. Although Spain offered to have the matter investigated and submitted to arbitration, the cause of the disaster was never discovered. The slogan "Remember the *Maine* and to Hell with Spain" was coined, and sailors of the era rushed in droves to have it tattooed on their chests before heading out to avenge her sinking. Already these types of tattoos had acquired the features which we recognize today: the curved scroll or banner with perhaps a slogan, name, or date; red, white, and blue bunting; the Stars and Stripes; a giant eagle as a backdrop. Even now, these are the quintessential features of many military and patriotic tattoos, easily recognized due precisely to their long traditional use.

Although distant in time and fading from memory, those early events and tattoos are a faint echo of the Gulf War tattoos of today or the "911" tattoos that became so popular around military bases nationwide in the aftermath of the September 11 attacks of 2001. Only fifty years ago, most servicemen simply made their tattoo choice based on flash (sample drawings of tattoos, typically arranged in posters on the walls) as they stood in a crowded tattoo studio and waited in line for their turn. Today, though, many different images and themes are melded by tattoo artists, and custom designs are not uncommon: Some Operation Iraqi Freedom designs have incorporated the name

of a unit or individual; the Statue of Liberty is paired with an outline of Iraq; the single word "Freedom" is done in the colors of the American flag. Entire military groups (men and women) are spontaneously acting in unity by getting the same tattoo before shipping out. And while the troops are deployed, the tattoo shops are not idle. Some receive a steady business from wives and other family members who are anxious to commemorate their patriotism and also their loved ones. However, of all the people who acquire patriotic tattoos, it is the people of the military who understand all too well the real risks associated with their profession. Tattoos placed on the underside of the arm (an area of the body which might escape damage from various types of assault) which record a serial number, blood type, or religious preference are a sobering reminder of those risks.

Military tattoos have likely taken an infinite number of forms in our collective past, from the horrific bluish green of Caesar's enemies or the black half-body of the Marquesan warriors to a simple scripted "U.S.A.F.," a full-blown "Screaming Eagle," the ever-popular banner of "Death Before Dishonor," or a well-muscled "Devil Dog," plus everything in between. While the modern military services are far from endorsing tattoos, each is faced with increasing numbers of members who are tattooed, and even heavily tattooed, as the popularity of tattoos in mainstream culture continues to rise. In fact, all branches of the service have recently revised their policies on what are considered appropriate images and placements for tattoos. Although never explicitly stated, such policies acknowledge the fact that the military and tattoos have a long tradition together. It is a tradition where personal history and military history become one and the same, captured in images and words in the skin. It is a tradition that has endured in many different forms and cir-

cumstances but with the fundamental experiences of building comradeship, creating identity with the group, and marking a transformation. Indeed, precisely for those reasons, it seems likely that the tradition of military tattooing is one which will not be ending any time soon.

Tattoo Regulations in the Military

In general, tattoo regulations in the different branches of the US military tend to be fairly similar, with three rules of thumb that seem to be applied consistently. First, absolutely forbidden are any tattoos that advocate any type of discrimination—racial, sexual, religious, or ethnic. Period. This rule can even apply if the tattoo can be covered by clothing. Second, speaking of clothing, tattoos shouldn't show when you're in uniform, especially the dress uniform (this gets back to the prevalent taboo against tattoos on the neck, head, or hands). Third, even with all the rules and regulations that each military branch has for tattoos, a person's commanding officer has the discretionary ability to rule on tattoos on a case-by-case basis. If you're considering a career in the military, as well as a new tattoo, check into the specific regulations for your particular branch of the service. While one branch may prohibit tattoos on the "neck," another will ban them "above the collarbone." One branch will offer exemptions to personnel who have been in the service for a long time, while another will offer free tattoo removal. Details, details, details—but they could be all important when it comes to your tattoo and how today's military decides to deal with it.

Resources

The Internet

The Body Art Newsgroup
rec.arts.bodyart

The Body Modification Ezine
www.bmezine.com

Sailor Jerry
www.sailorjerry.com

Tattoos.com
www.tattoos.com

The Tattoo Archive
www.tattooarchive.com

The Tattoo Directory
www.tattoodirectory.com

The Vanishing Tattoo
www.vanishingtattoo.com

Magazines

International Tattoo Art
www.internationaltattooart.com

Machine Gun Magazine—Hotrod Tattoo Machine Bible
www.machinegunmagazine.com

Prick Magazine
www.prickmag.net

Skin Art Magazine
www.skinart.com

Skin & Ink Magazine
www.skinandink.com

Tattoo Magazine, Flash, & Savage Magazine
www.easyriders.com

Organizations

Alliance of Professional Tattooists
www.safe-tattoos.com

The Australian Museum Online
http://www.austmus.gov.au/bodyart/tattooing/index.htm

The Japan Tattoo Institute
www.keibunsha.com

National Maritime Museum-Skin Deep Exhibition
www.nmm.ac.uk/site/navId/005001005000003

The National Tattoo Association
www.nationaltattooassociation.com

The Tattoo Club of Great Britain
www.tattoo.co.uk

Books that I've found useful or interesting include:

Atkinson, Michael. *Tattooed: The Sociogenesis of a Body Art.* University of Toronto Press, 2003.

Barbieri, Gian Paolo. *Tahiti Tattoos.* Taschen, 1998.

Blackburn, Mark. *Tattoos from Paradise: Traditional Polynesian Patterns.* Schiffer, 1999.

Caplan, Jane, ed. *Written on the Body: The Tattoo in European and American History.* Princeton University Press, 2000.

Carswell, John. *Coptic Tattoo Designs.* The Faculty of Arts and Sciences, The American University of Beirut, 1958.

Demello, Margo. *Bodies of Inscription: A Cultural History of the Modern Tattoo Community.* Duke University Press, 2000.

Demello, Margo, and Alan B. Govenar, Don Ed Hardy, Michael McCabe, Mark C. Taylor. *Pierced Hearts and True Love: A Century of Drawings for Tattoos.* Hardy Marks Publications, 1996.

DeMichele, William. *The Illustrated Woman.* Proteus Press, 1992.

Dinter, Maarten Hesselt van. *Tribal Tattoo Designs*. Shambhala Publications, 2000.

Fellman, Sandi. *The Japanese Tattoo*. Abbeville Press, 1986.

Fellowes, C. H. *The Tattoo Book*. Pyne Press, 1971.

Ferguson, Henry, and Lynn Procter. *The Art of the Tattoo*. Courage Books, 1998.

Gell, Alfred. *Wrapping in Images: Tattooing in Polynesia*. Clarendon Press, 1996.

Gilbert, Steve. *Tattoo History: A Source Book*. Juno Books, 2000.

Hall, Douglas Kent. *Prison Tattoos*. St. Martin's Griffin, 1997.

Hambly, W. D. *The History of Tattooing and Its Significance: With Some Account of Other Forms of Corporal Marking*. H. F. & G. Witherby, 1925.

Handy, Willowdean. *Forever the Land of Men: An Account of a Visit to the Marquesas Islands*. Dodd, Mead, & Company, 1965.

Hardy, Don Ed, ed. *New Tribalism (Tattootime)*. Hardy Marks, 1988.

———. *Tattoo Magic (Tattootime 2)*. Hardy Marks, 1988.

———. *Music and Sea Tattoos (Tattootime 3)*. Hardy Marks, 1988.

———. *Life and Death Tattoos (Tattootime 4)*. Hardy Marks, 1988.

———. *Art from the Heart (Tattootime 5)*. Hardy Marks, 1991.

———. *Sailor Jerry Collins, American Tattoo Master: In His Own Words*. Hardy Marks, 1994.

Kitamura, Takahiro. *Tattoos of the Floating World: Ukiyo-e Motifs in the Japanese Tattoo*. Hotei Publishing, 2003.

Kitamura, Takahiro, and Katie M. Kitamura. *Bushido: Legacies of the Japanese Tattoo*. Schiffer Publishing, 2001.

Kwiatkowski, P. F. *The Hawaiian Tattoo.* Halona, Inc., 1996.

Leighton, Peter, ed. *Memoirs of a Tattooist: From the Notes, Diaries and Letters of the Late "King of the Tattooists," George Burchett.* Oldbourne, 1958.

Marquardt, Carl. *The Tattooing of Both Sexes in Samoa.* R. McMillan, 1984 (originally published by Verlag von Dietrich Reimer, 1899).

Mifflin, Margot. *Bodies of Subversion: A Secret History of Women and Tattoo.* Juno Books, 2001.

Neleman, Hans. *Moko: Maori Tattoo.* Stemmle Publishers, 1999.

Paleari, Fabio. *The Leu Family's Family Iron.* Trolley, 2003.

Richie, Donald, and Ian Buruma. *The Japanese Tattoo.* Weatherhill, 1995.

Robley, H. G. *Maori Tattooing.* Dover, 2003 (originally published by Chapman and Hall, 1896).

Rubin, Arnold, ed. *Marks of Civilization.* Museum of Cultural History, University of California, Los Angeles, 1988.

Sato, Nobuo. *Write Your Name in Kanji.* Tuttle Publishing, 1996.

Schiffmacher, Henk. *1000 Tattoos.* Taschen, 1996.

Scutt, R.W.B., and Christopher Gotch. *Art, Sex and Symbol: The Mystery of Tattooing.* Cornwall Books, 1986.

Vale, V., and Andrea Juno, eds. *Modern Primitives: An Investigation of Contemporary Adornment & Ritual.* Re/search Publications, 1989.

Valentine, Bill. *Gangs and Their Tattoos: Identifying Gangbangers on the Street and in Prison.* Paladin Press, 2000.

von Glinski, Gregor. *Masters of Tattoo.* Stemmle Publishers, 1998.

Webb, Spider. *Tattooed Women.* Schiffer Publishing, 1982.

———. *The Big Book of Tattoo.* Schiffer Publishing, 2002.

Wroblewski, Chris. *Skin Shows: The Art of Tattoo.* W. H. Allen & Co., 1989.

———. *Skin Shows II: The Art of Tattoo.* Carol Publishing Group, 1991.

———. *Skin Shows III: The Art of Tattoo.* Virgin Publishing, 1993.